Dragon Dreams

Adult Therapy colouring book
A fabulous collection of dragons
by

Morgan Fitzsimons

Copyright Morgan Fitzsimons 2016
All rights reserved by the Artist

Fae Entertainment & Fae Workshop

www.fae-entertainment.com
www.morganfitzsimons.com
info@fae-entertainment.ca

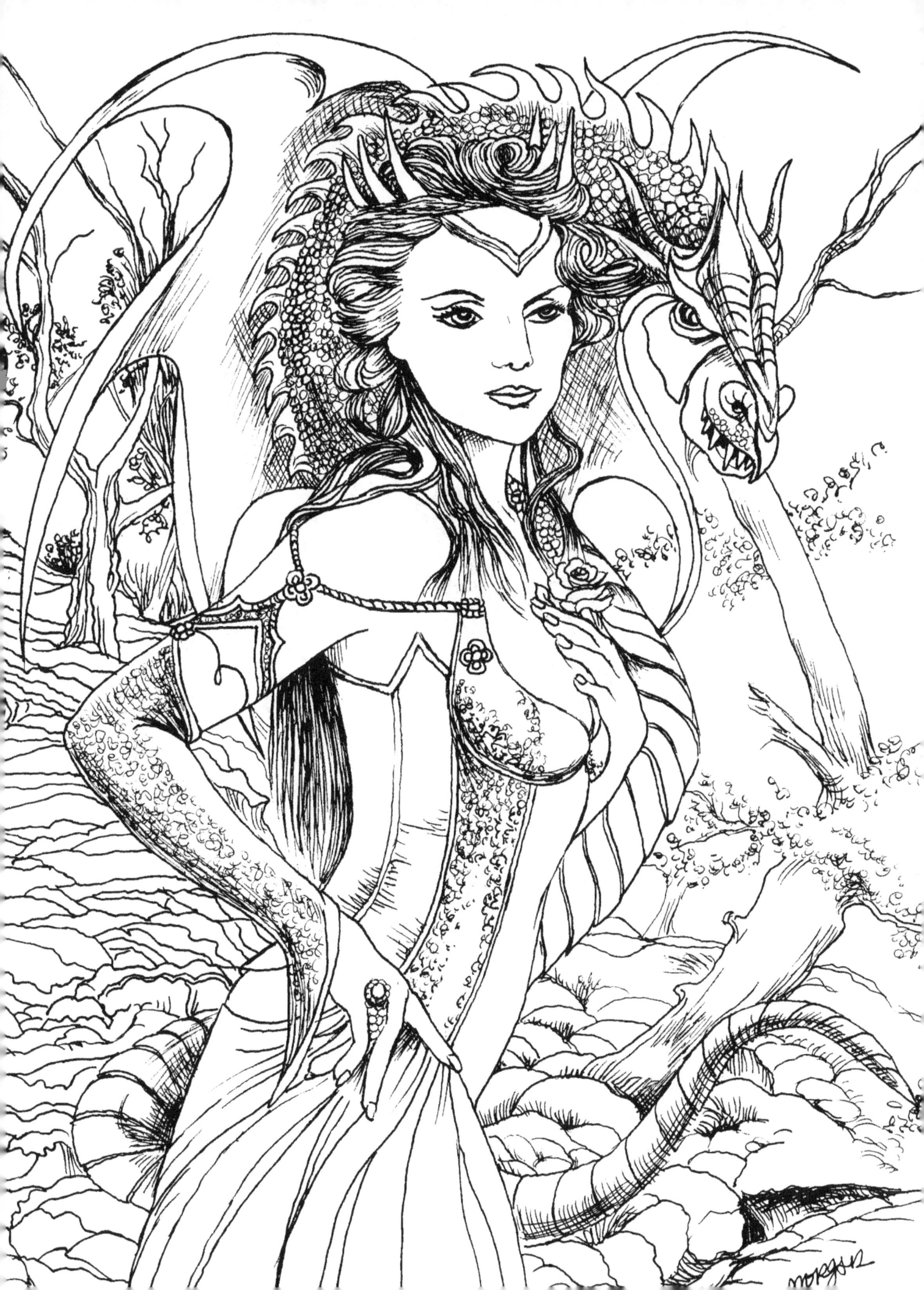

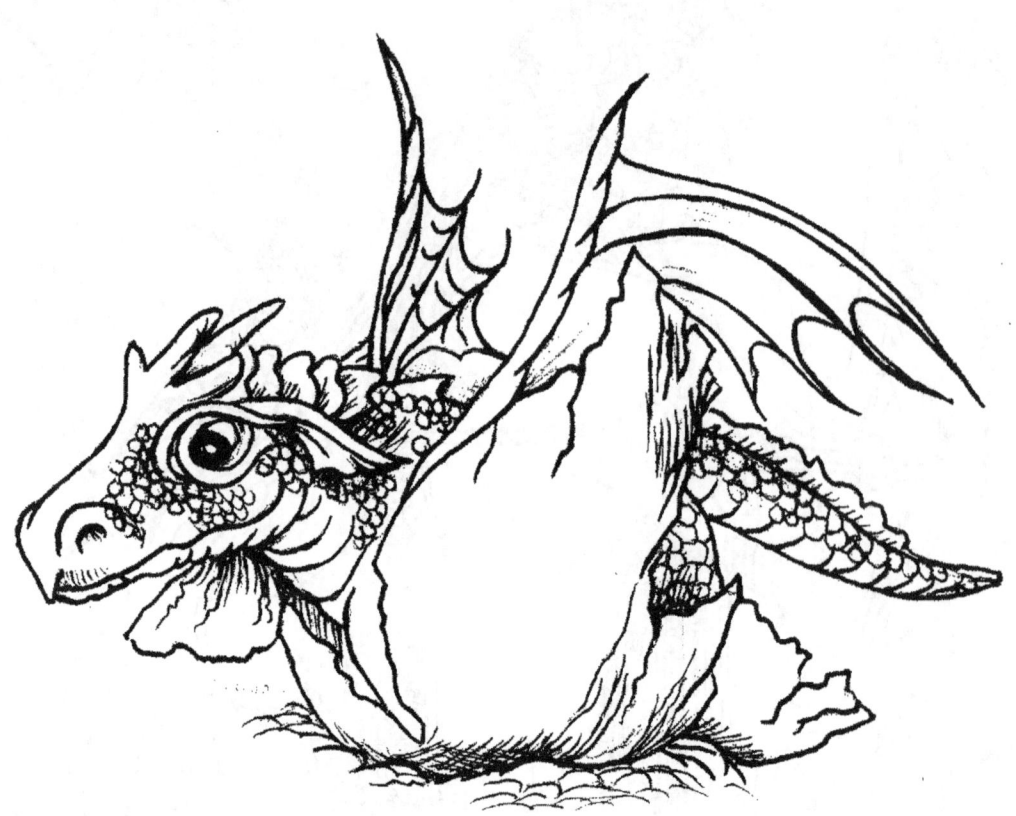

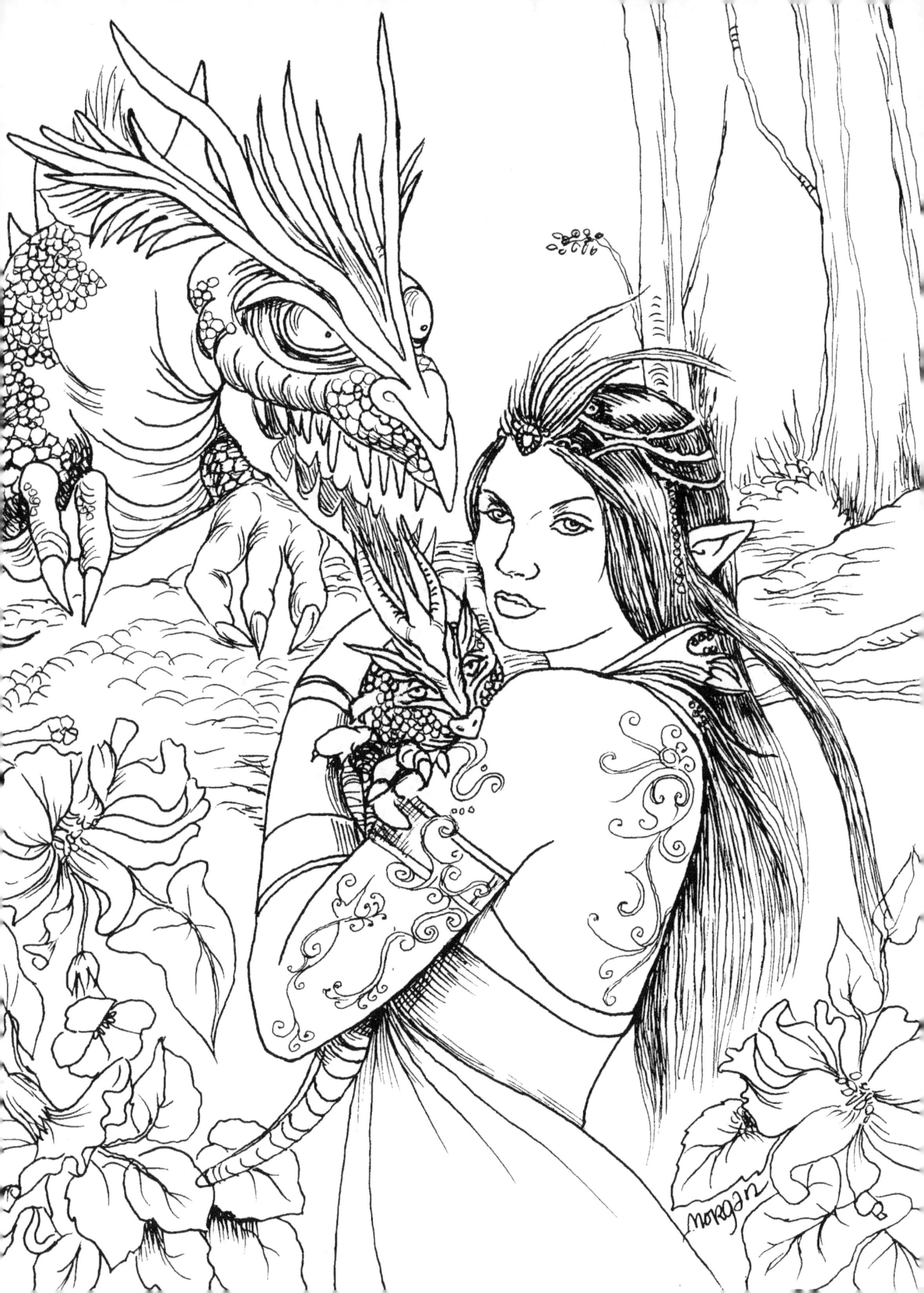

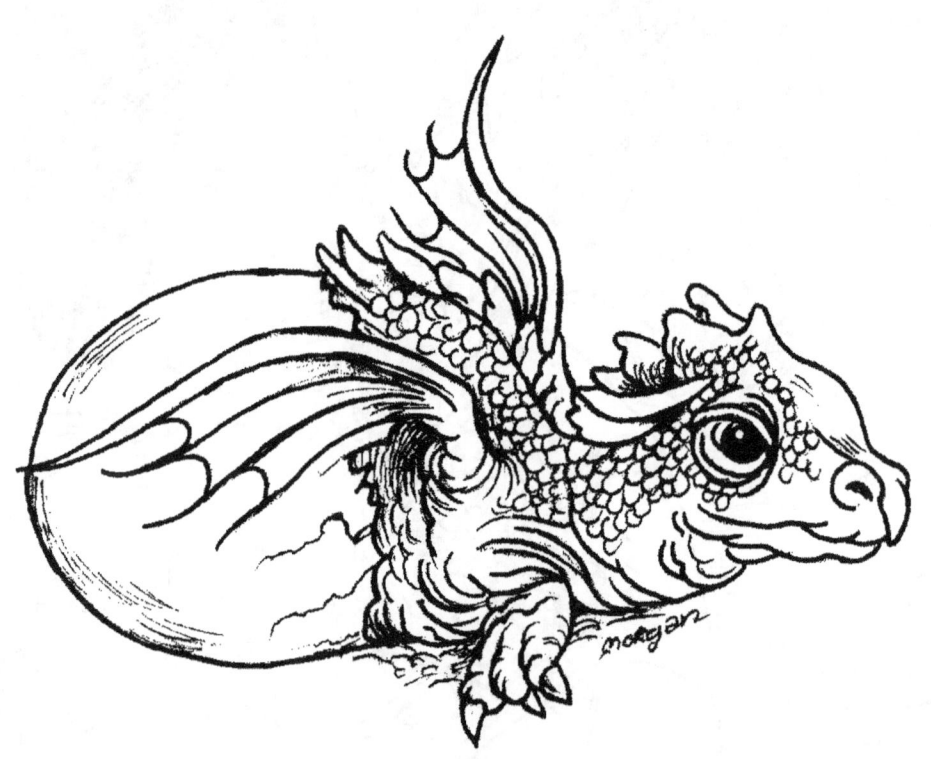

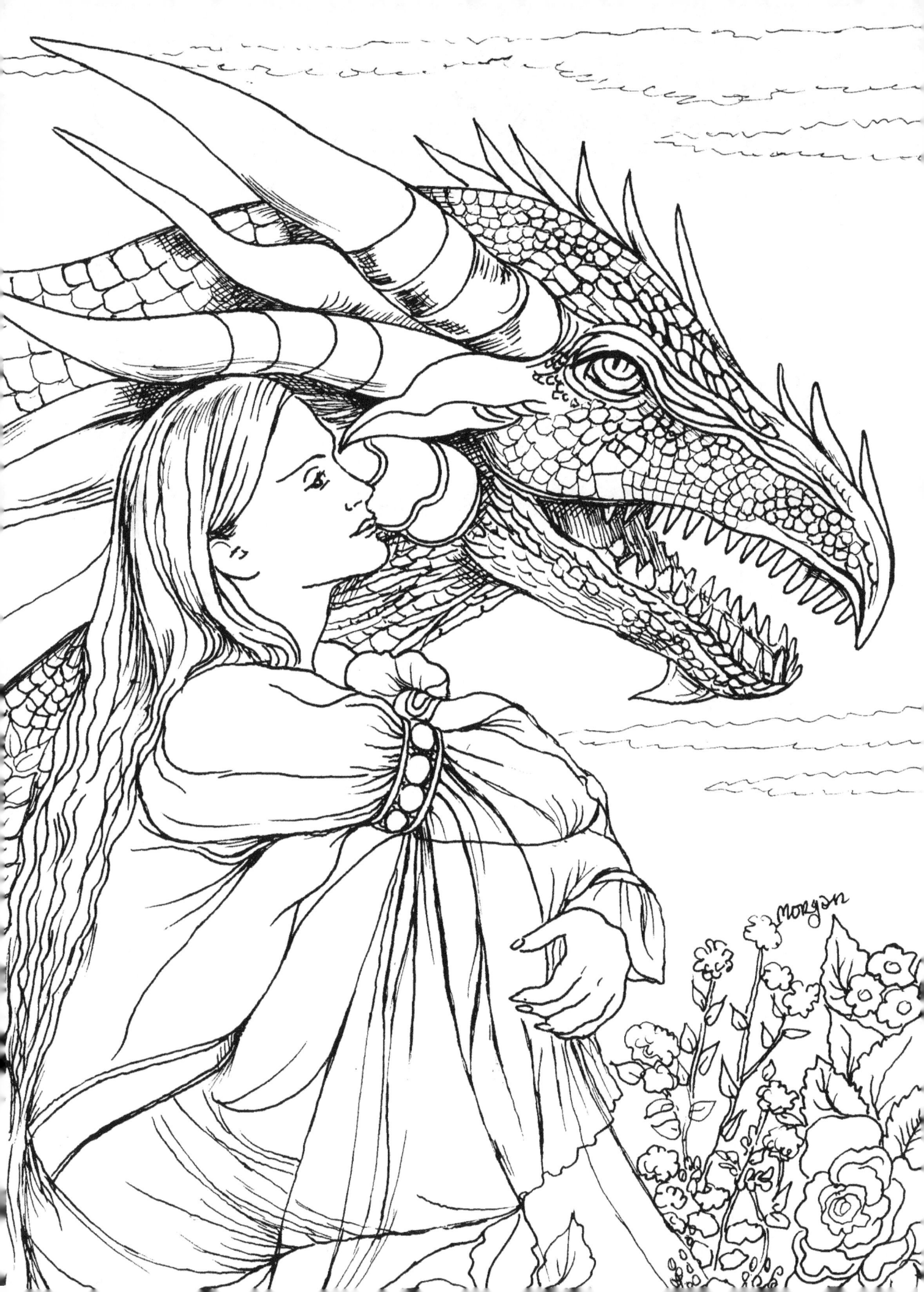

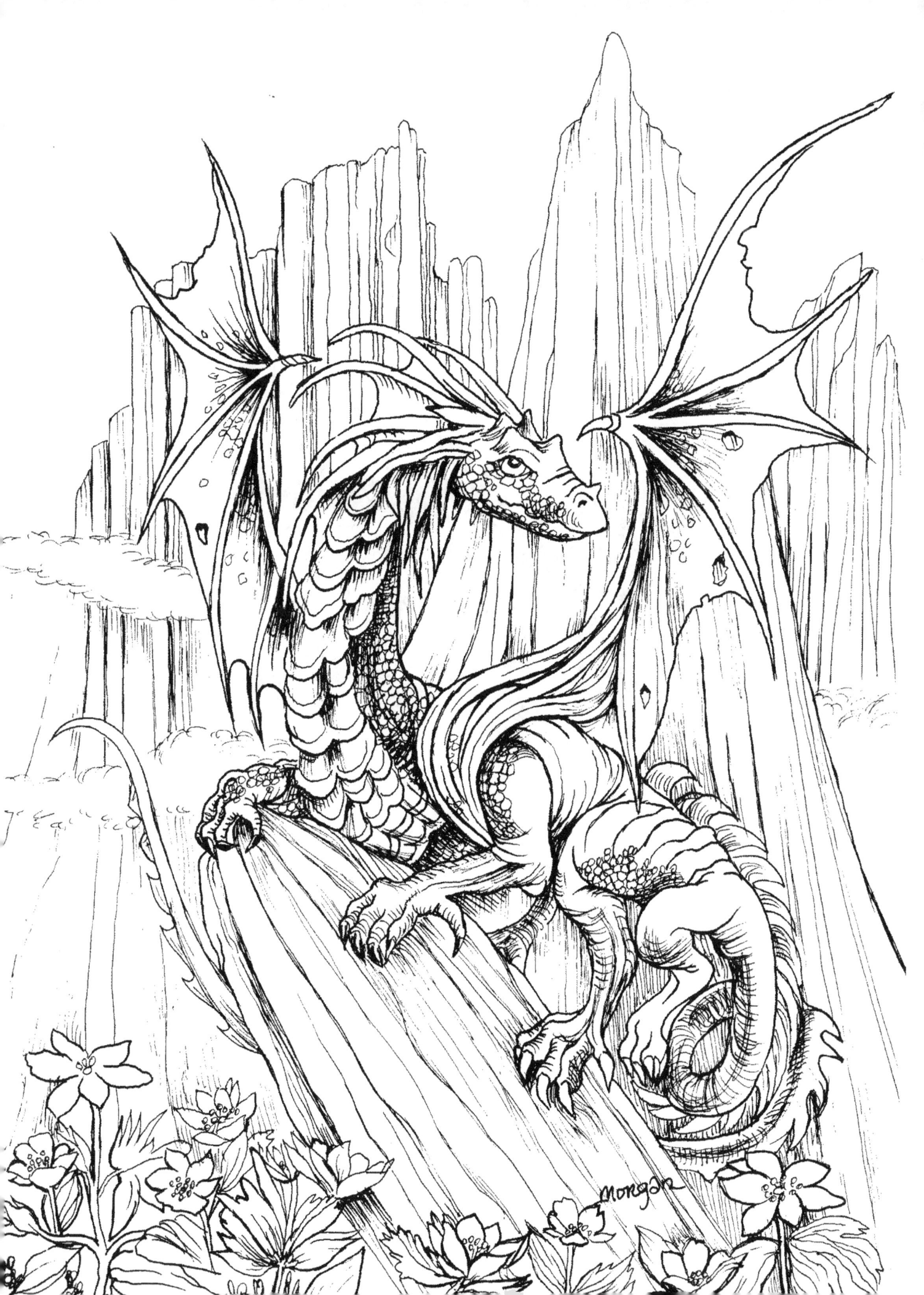

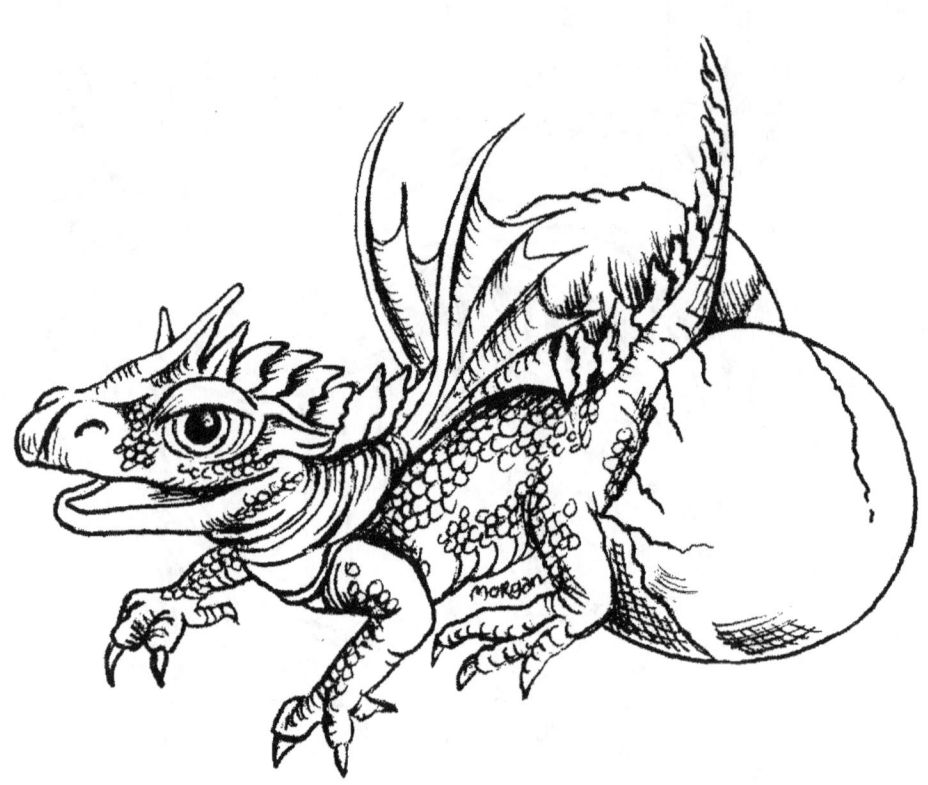

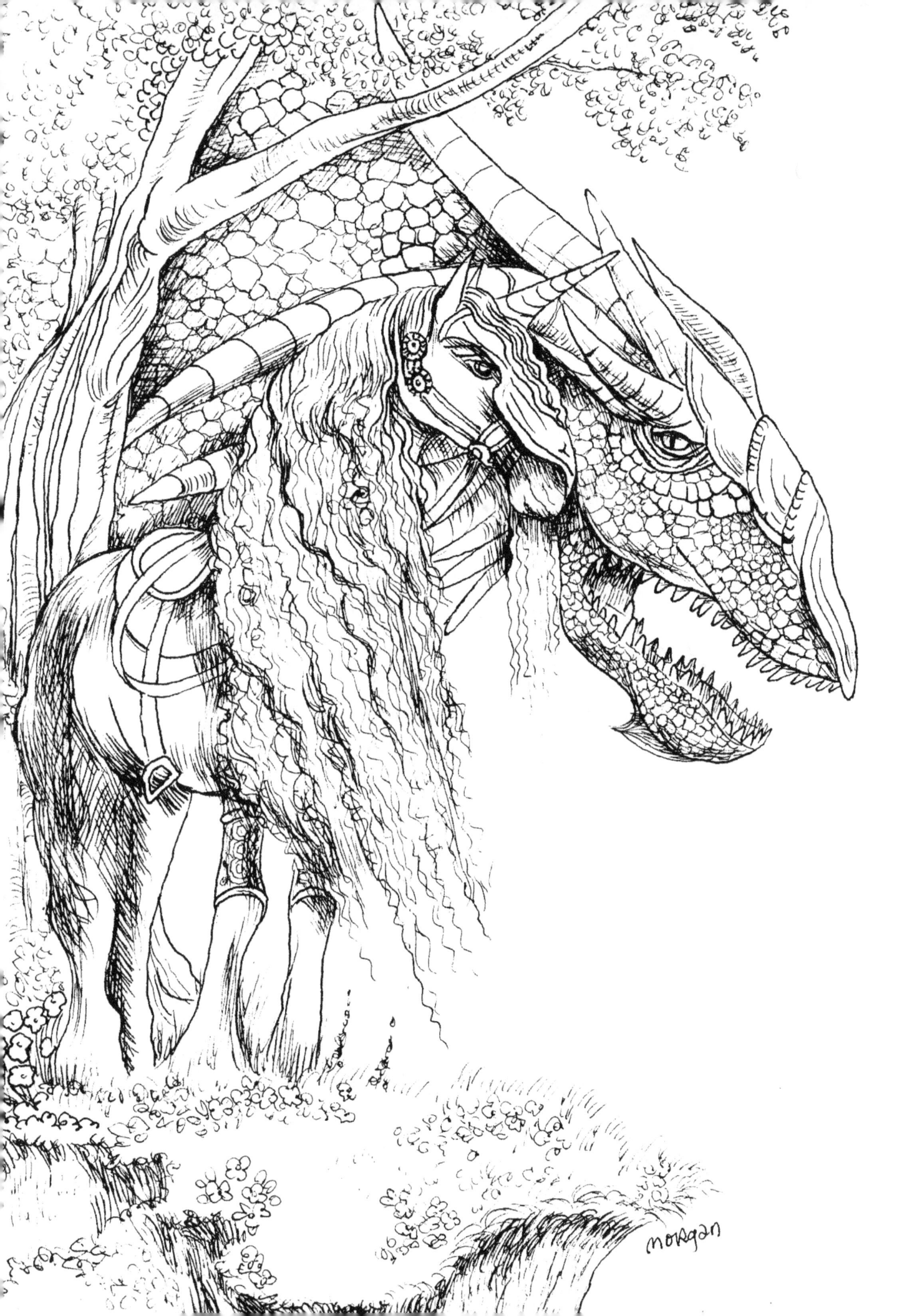

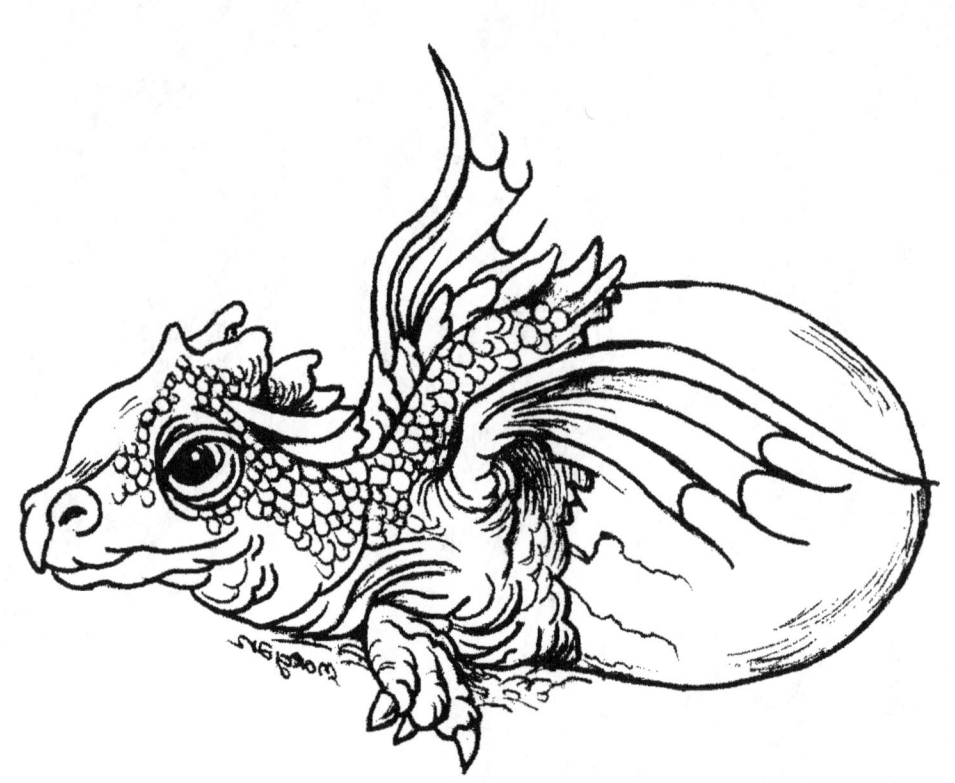

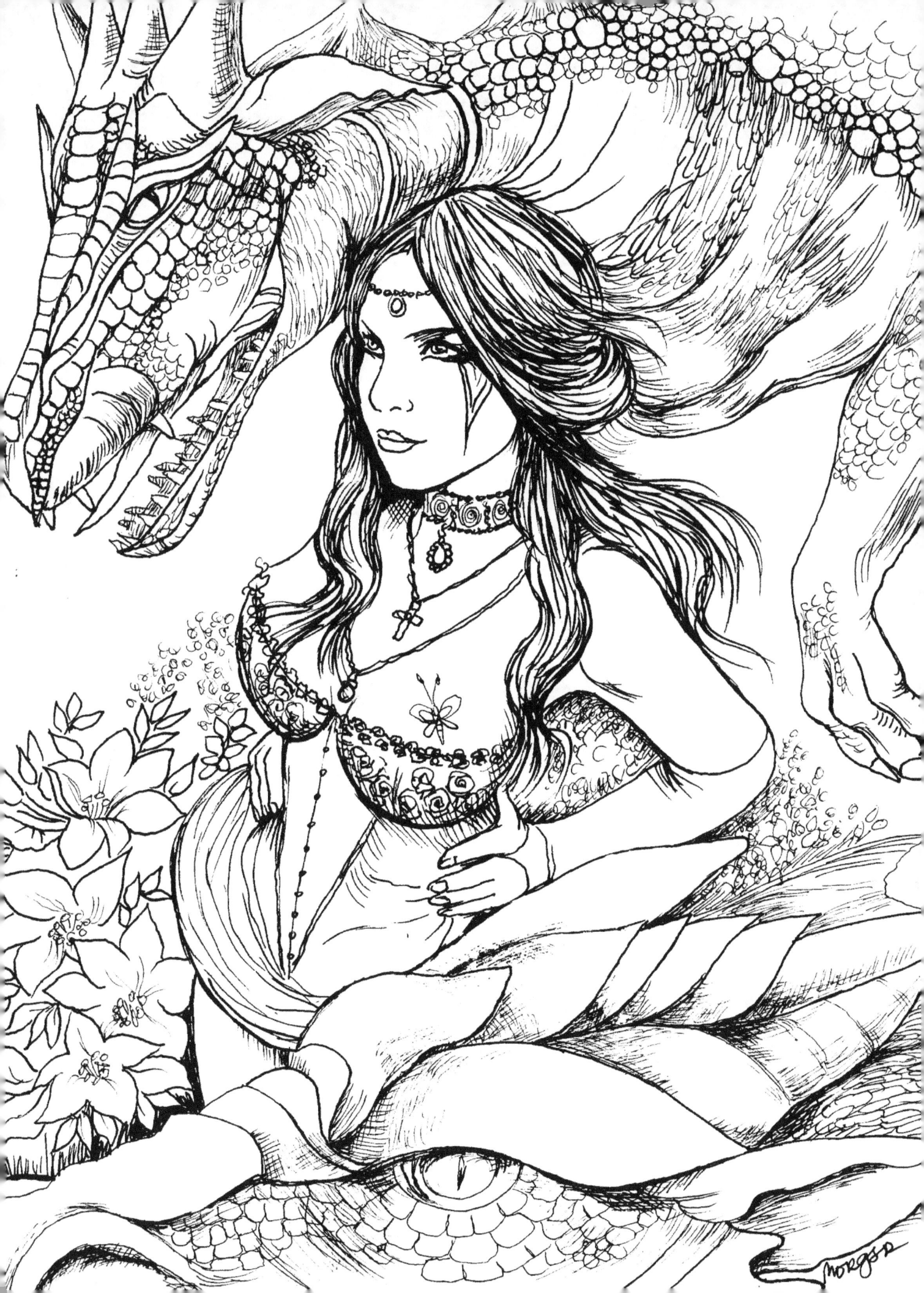

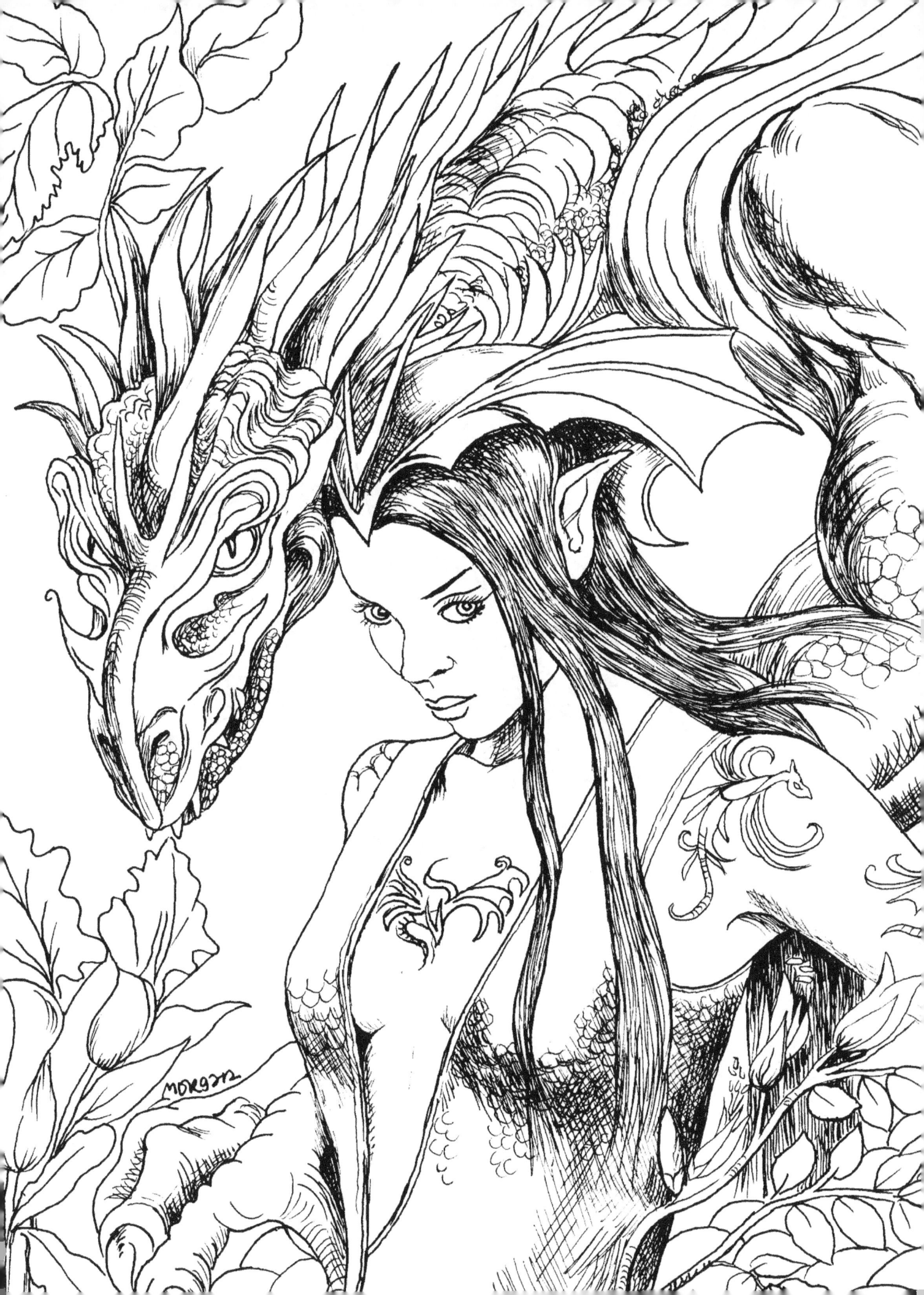

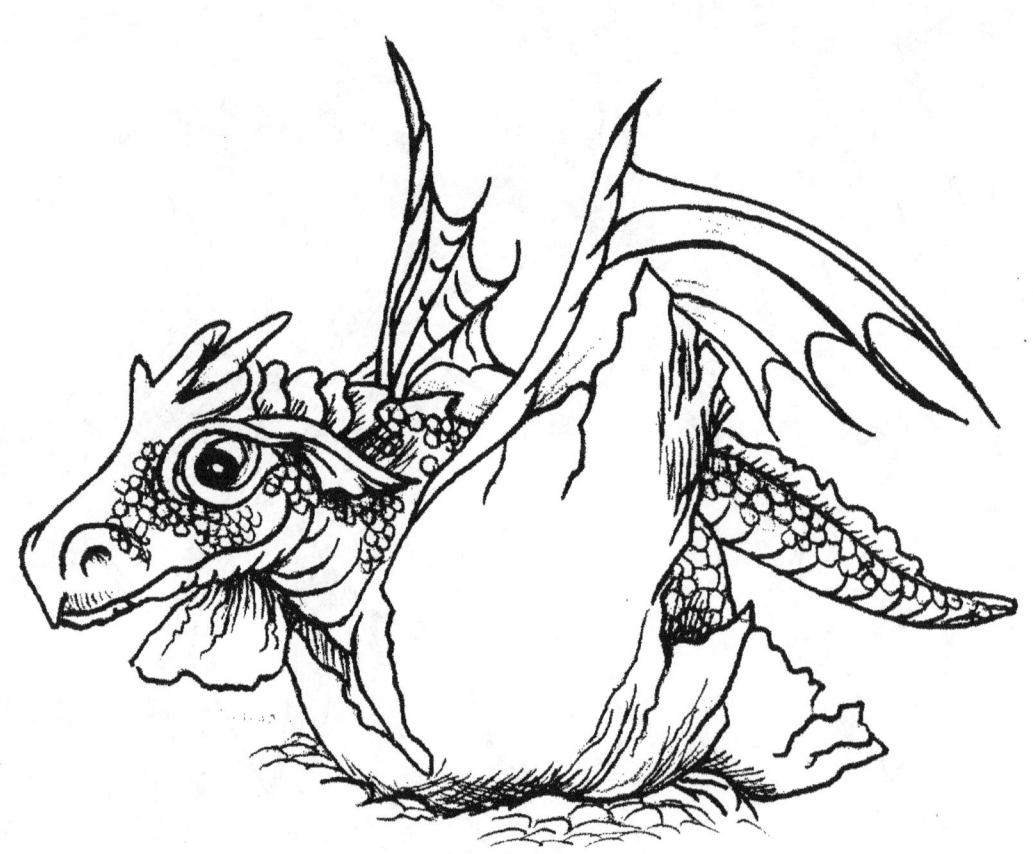

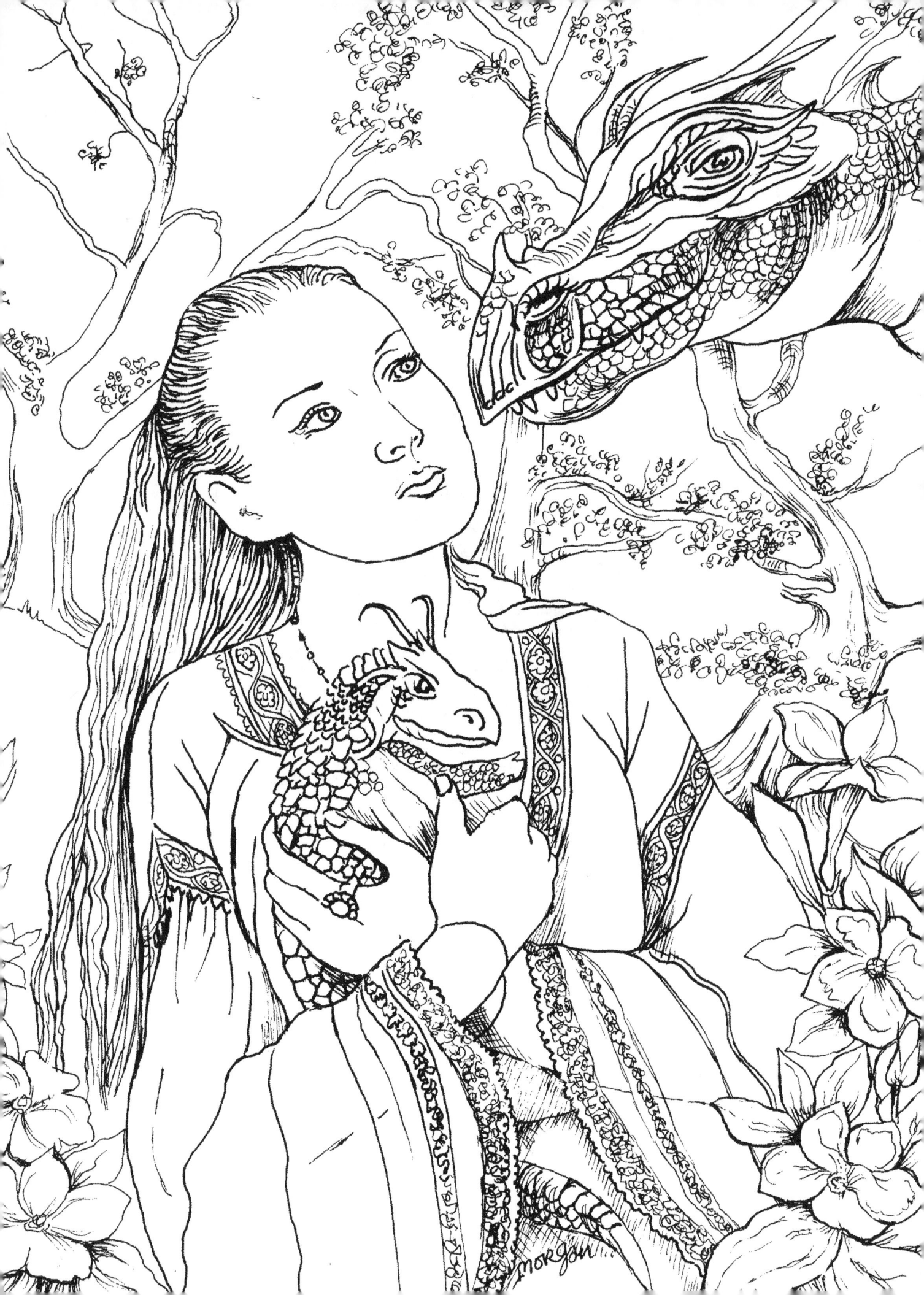

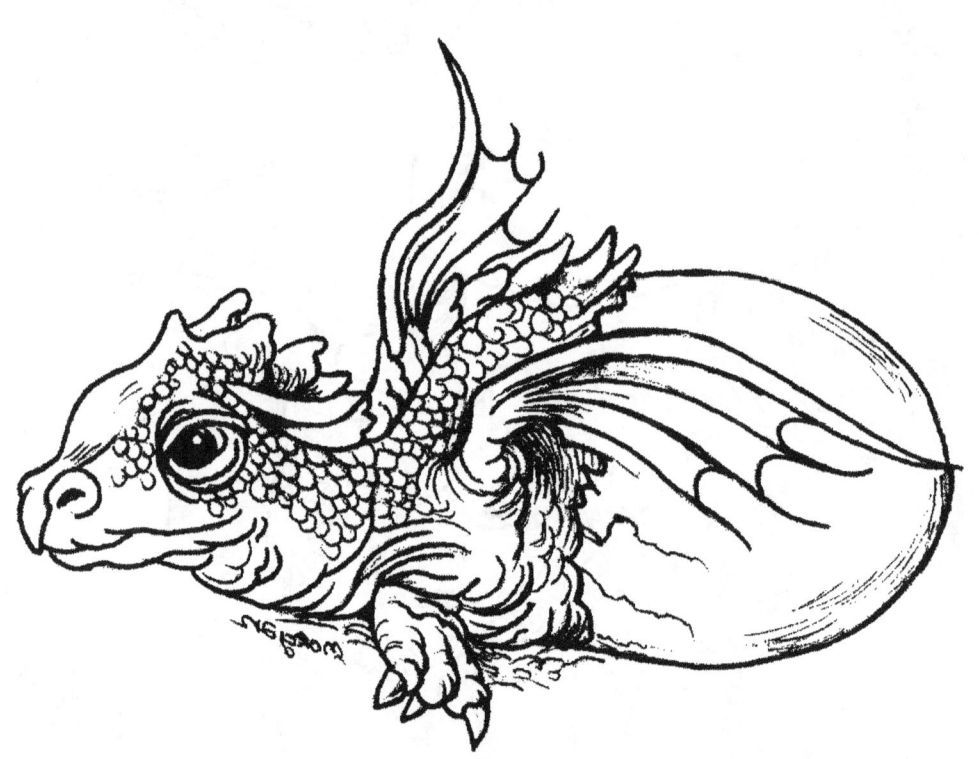

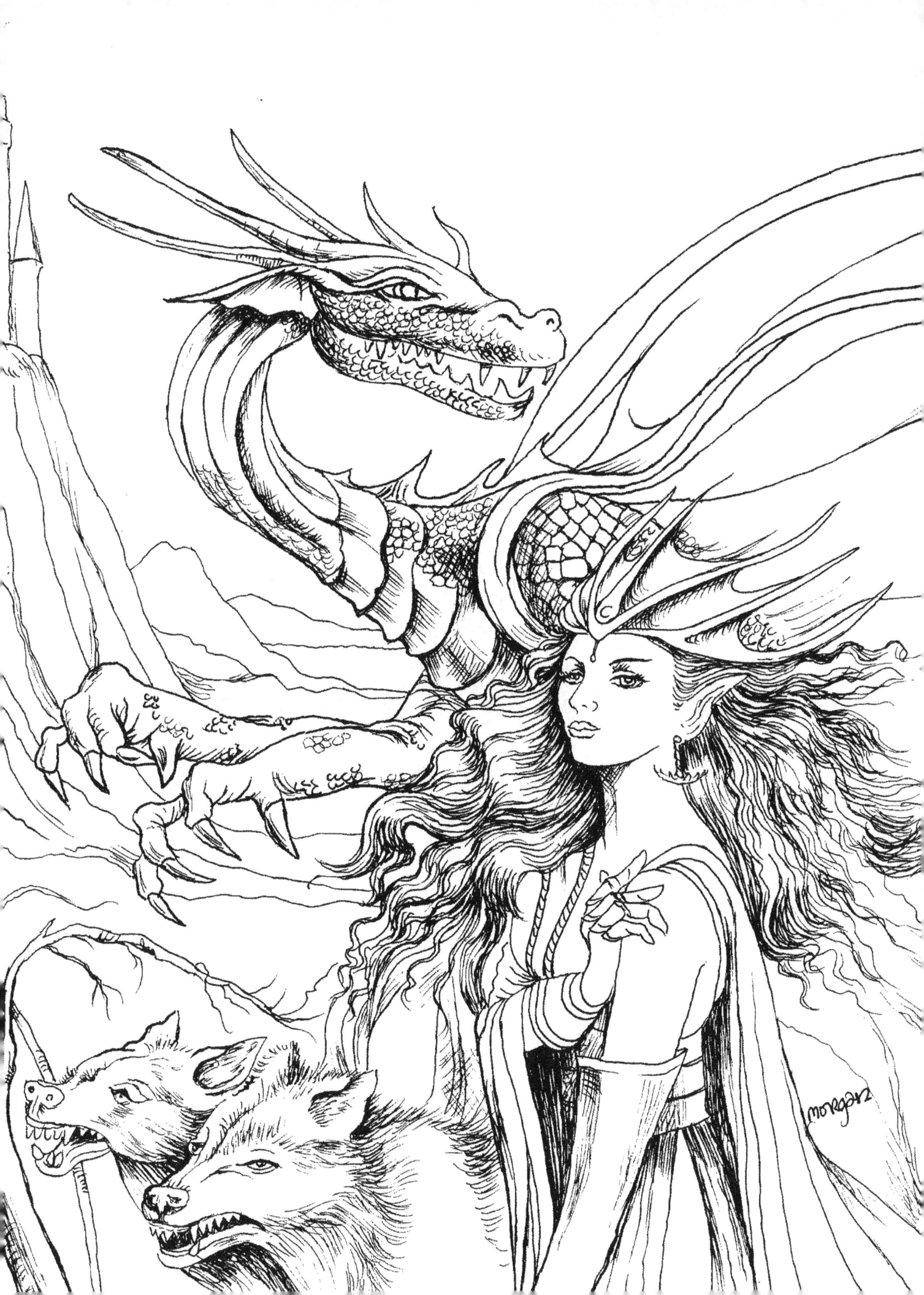

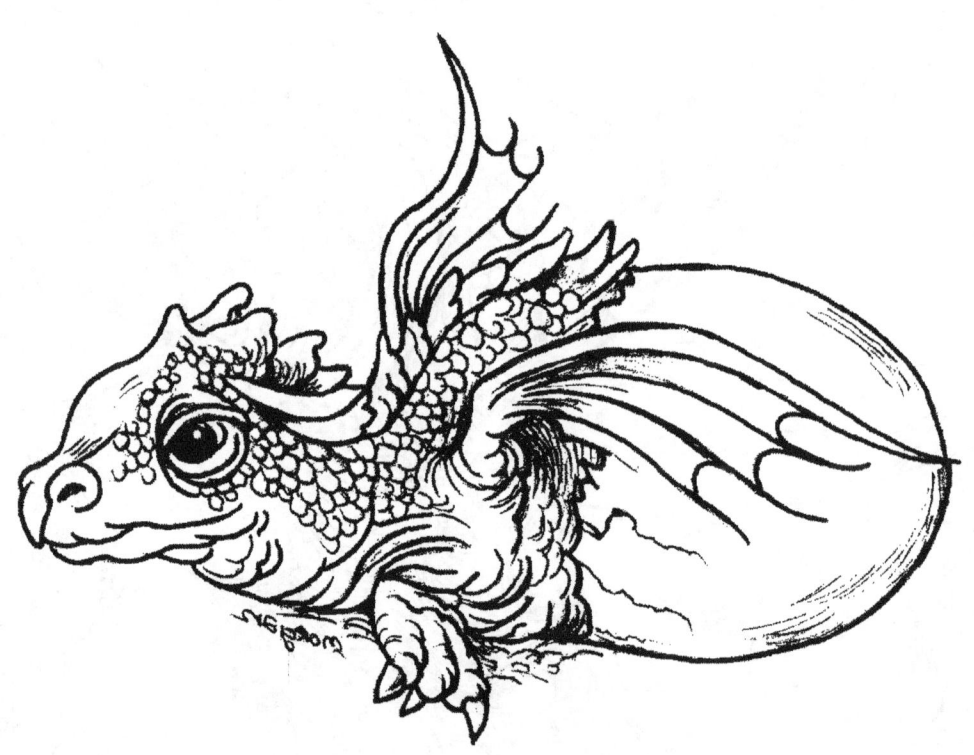

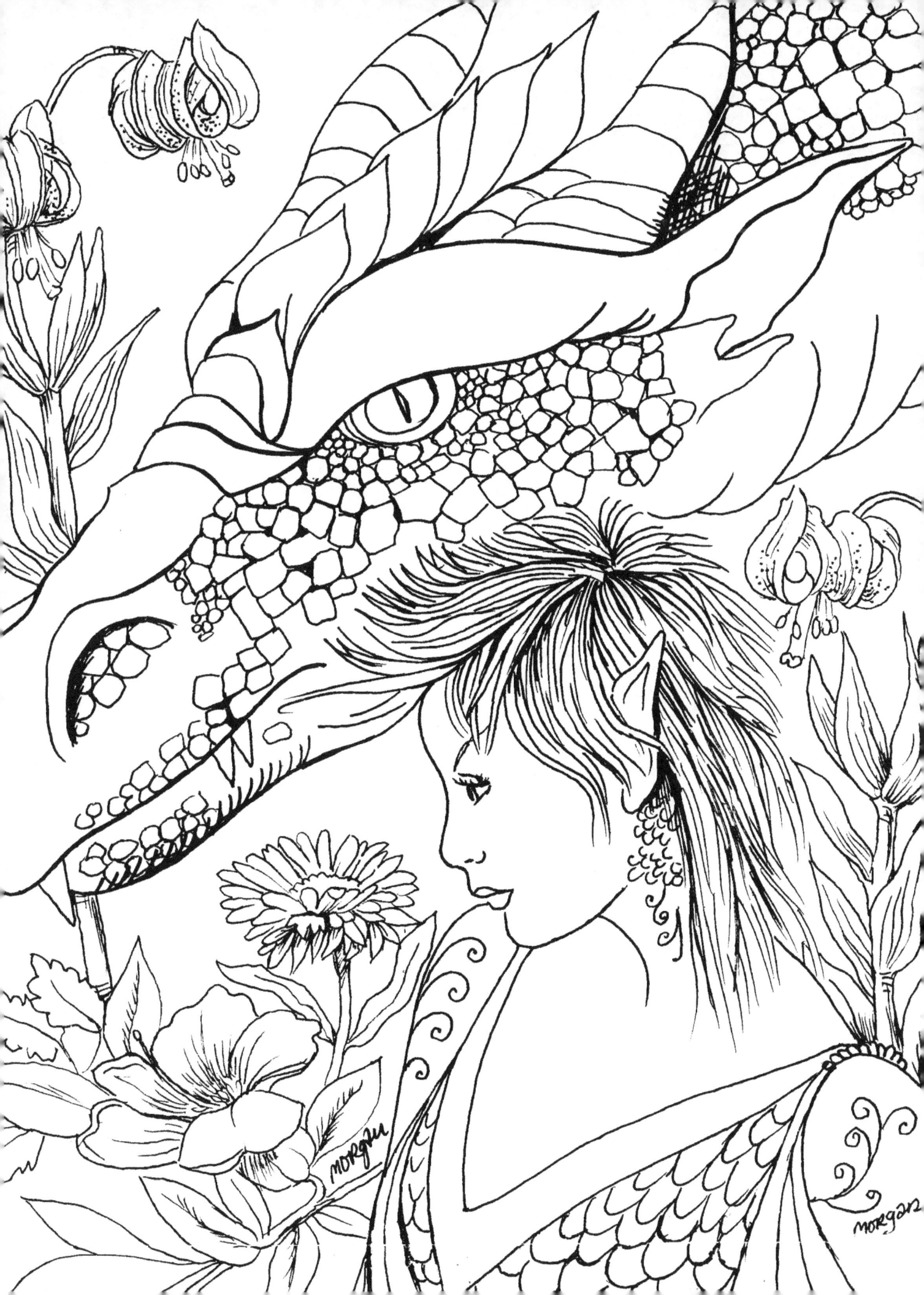

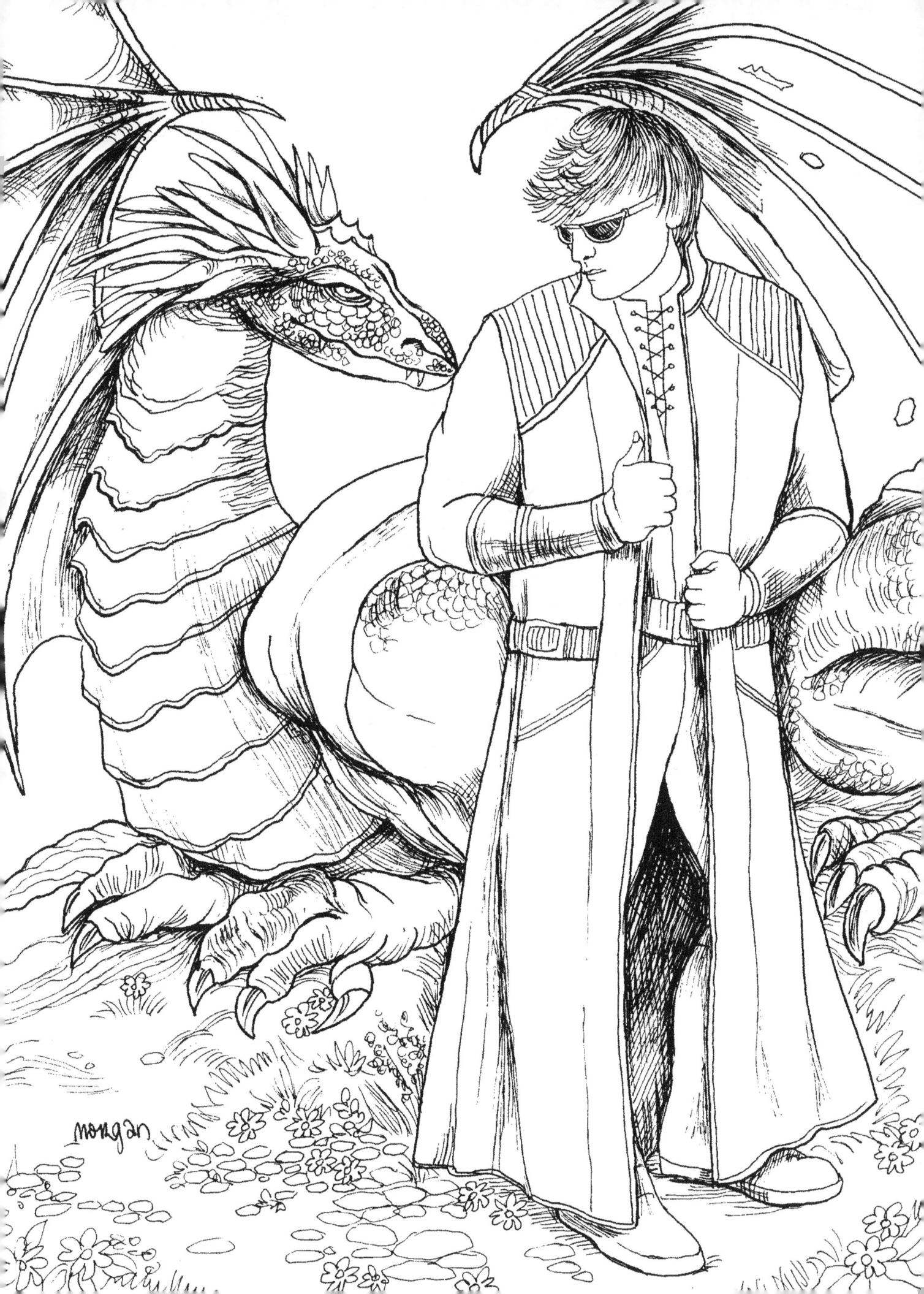

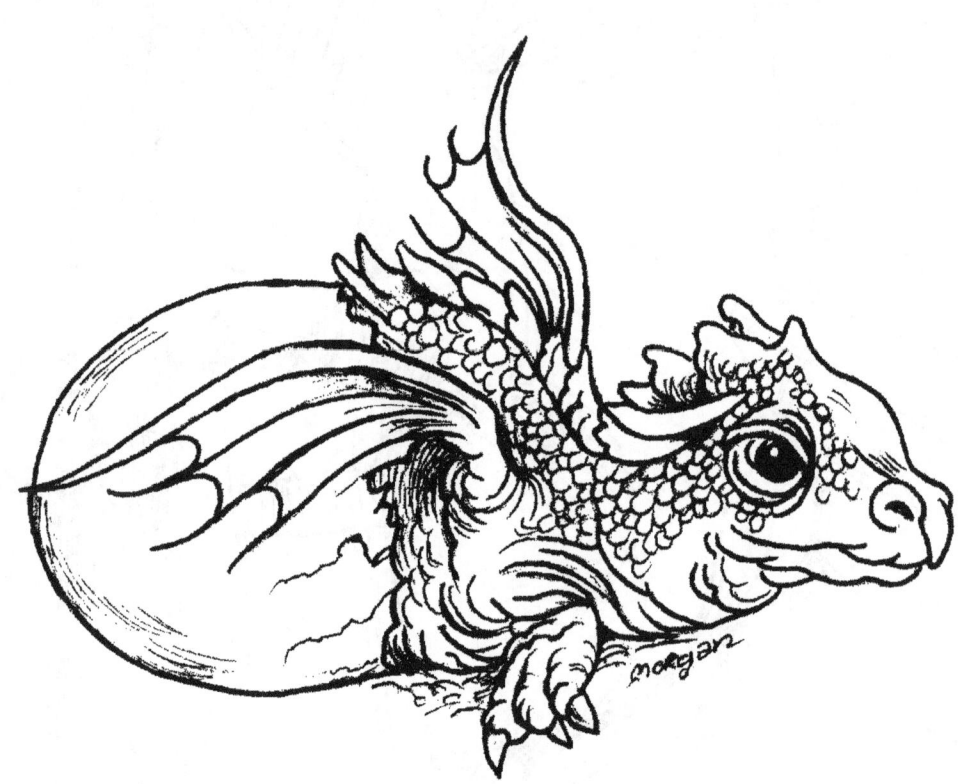

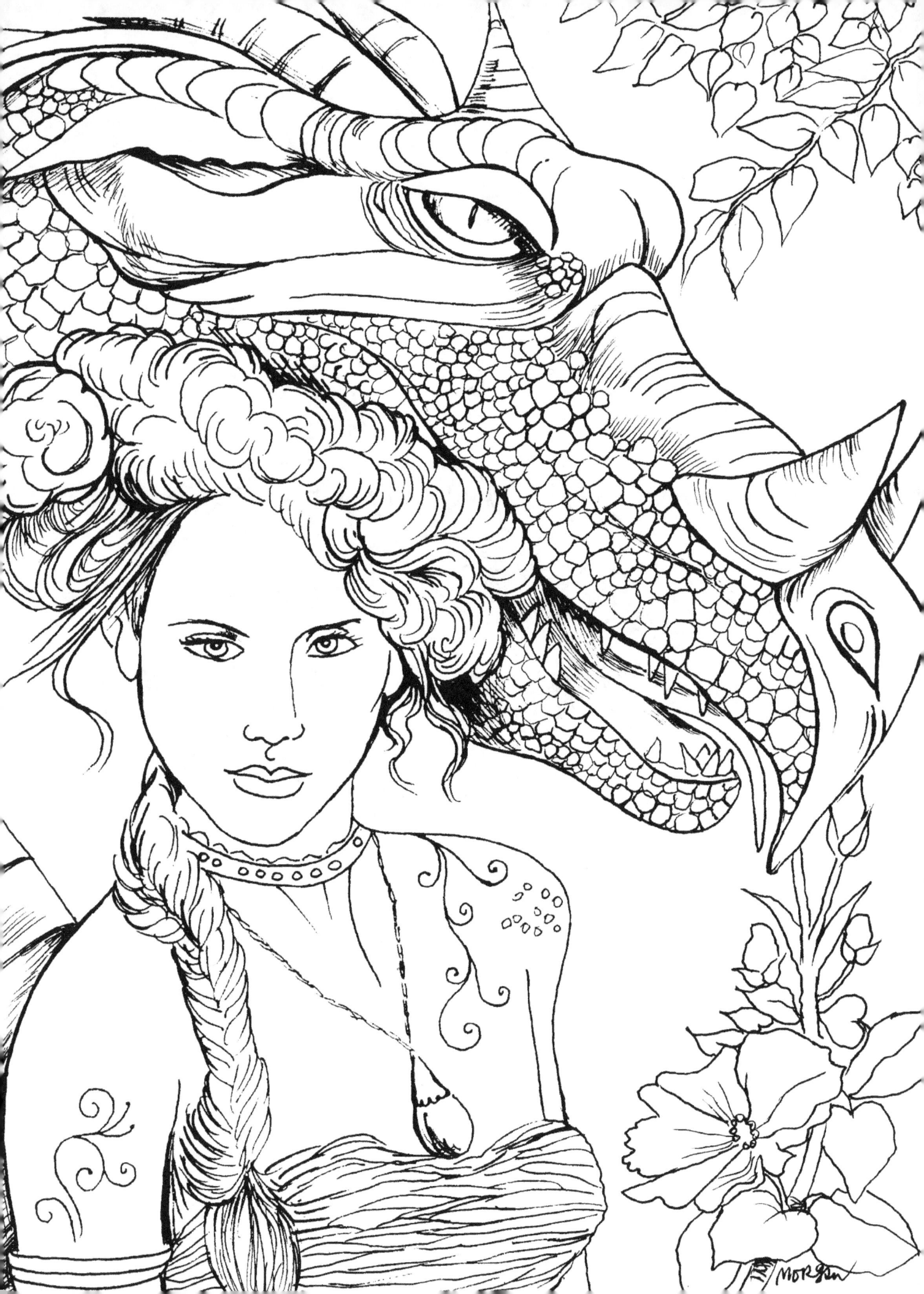

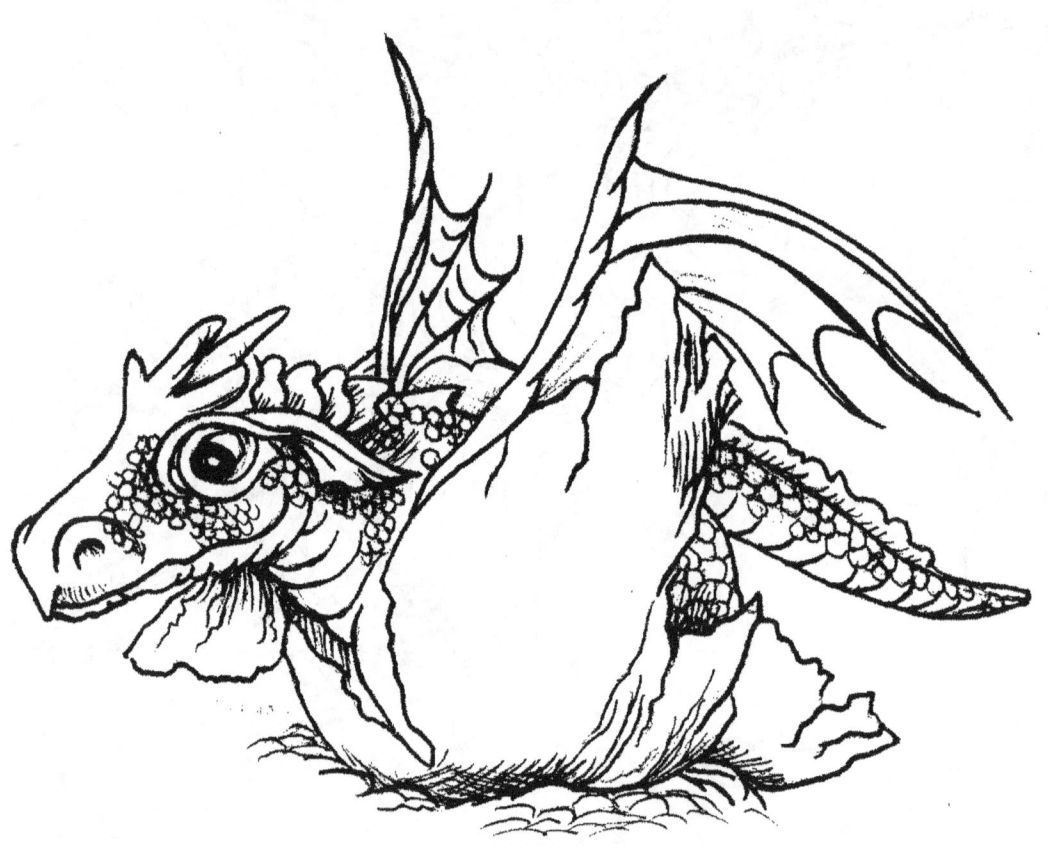

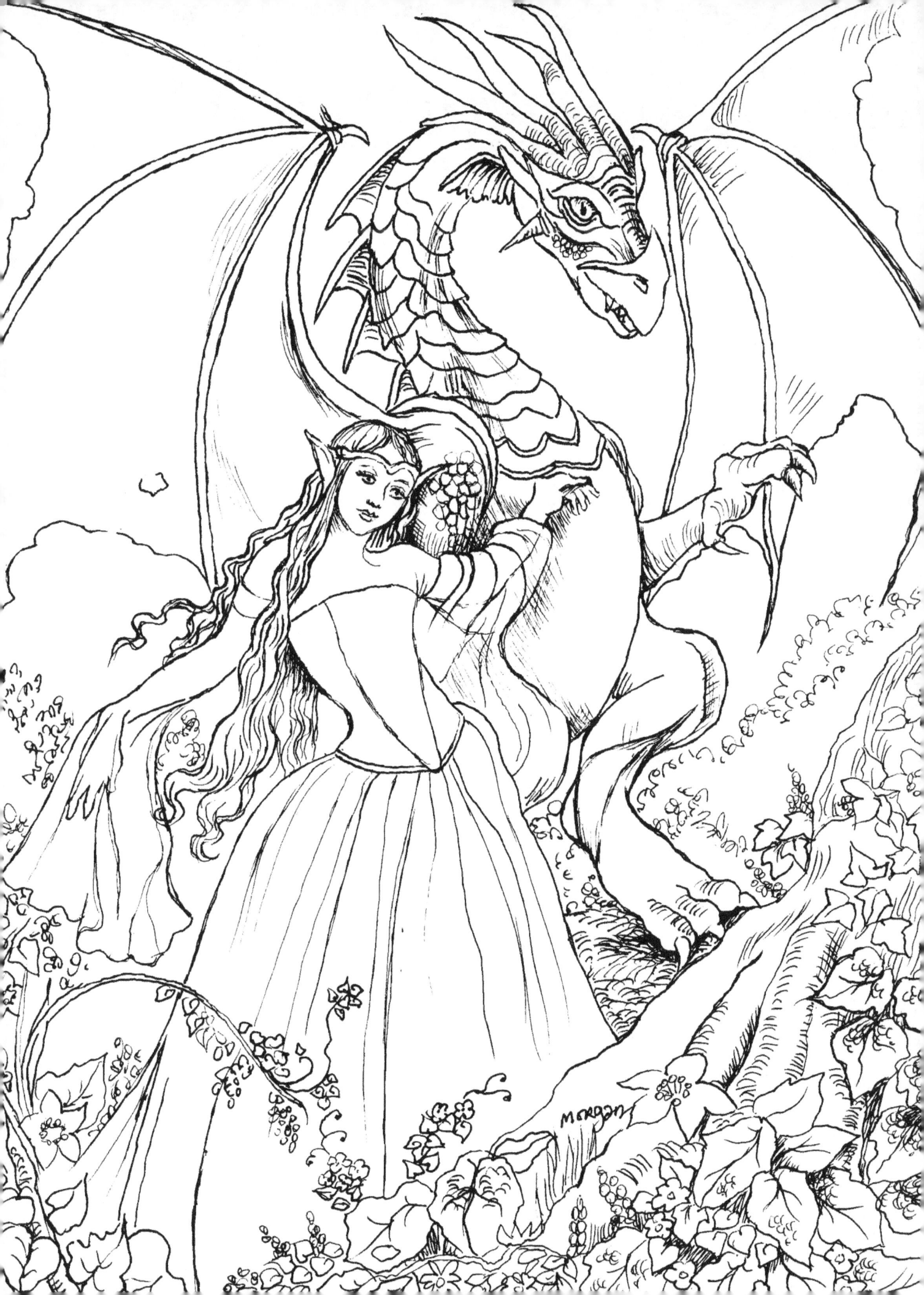

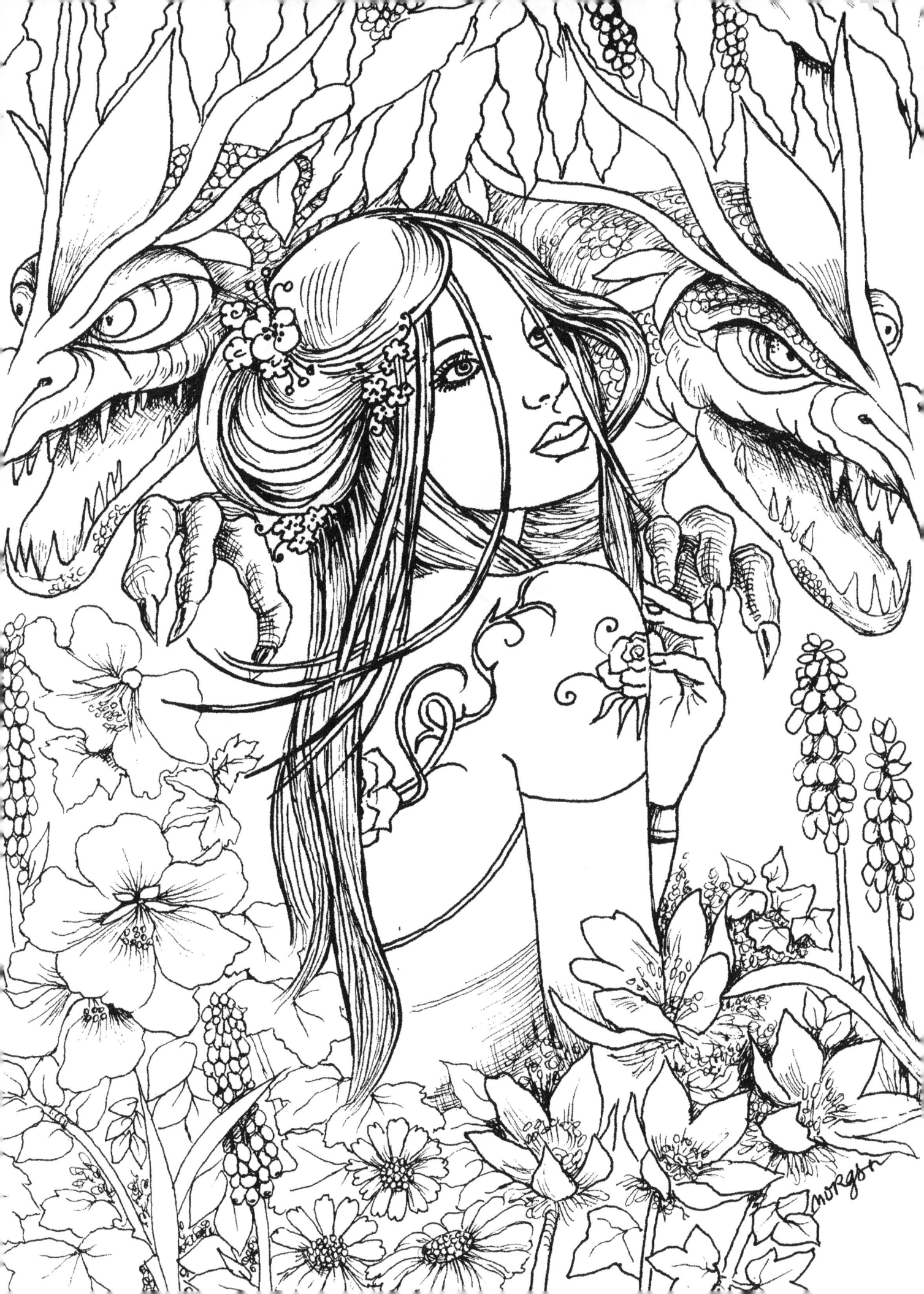

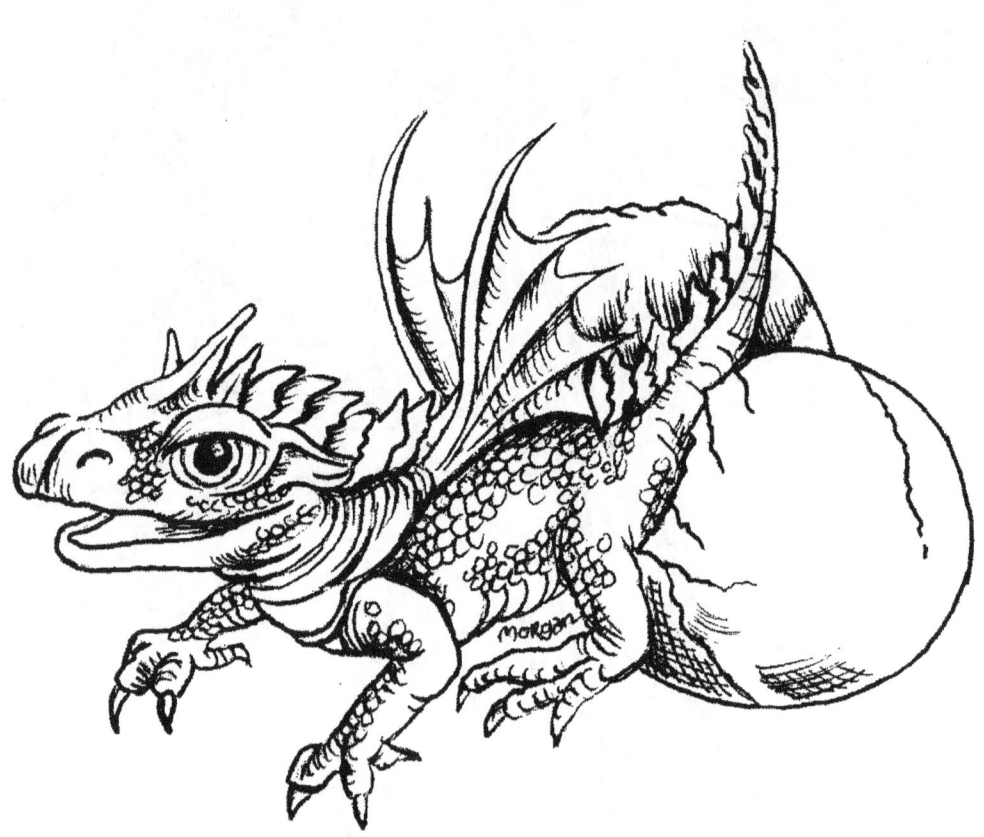

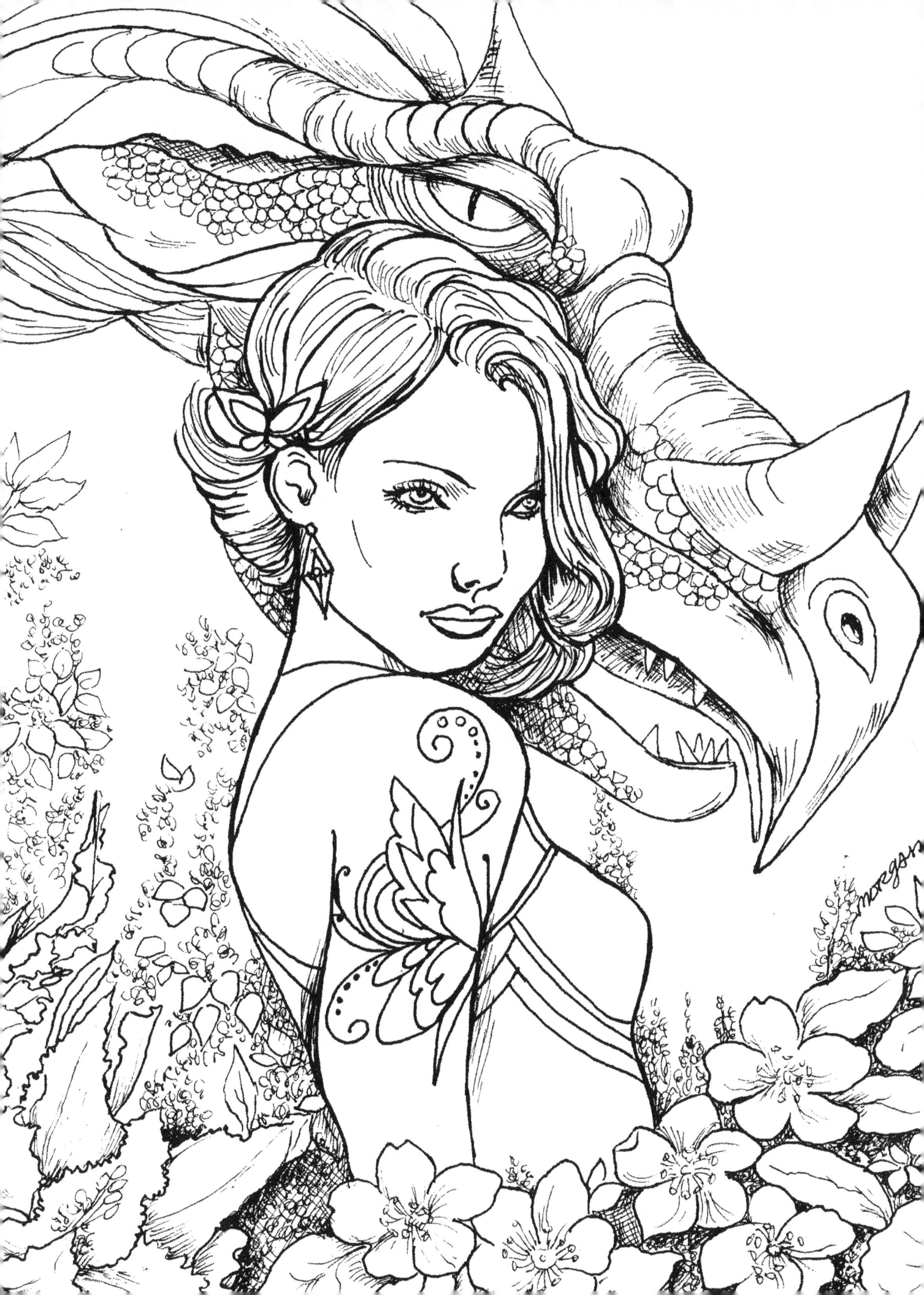

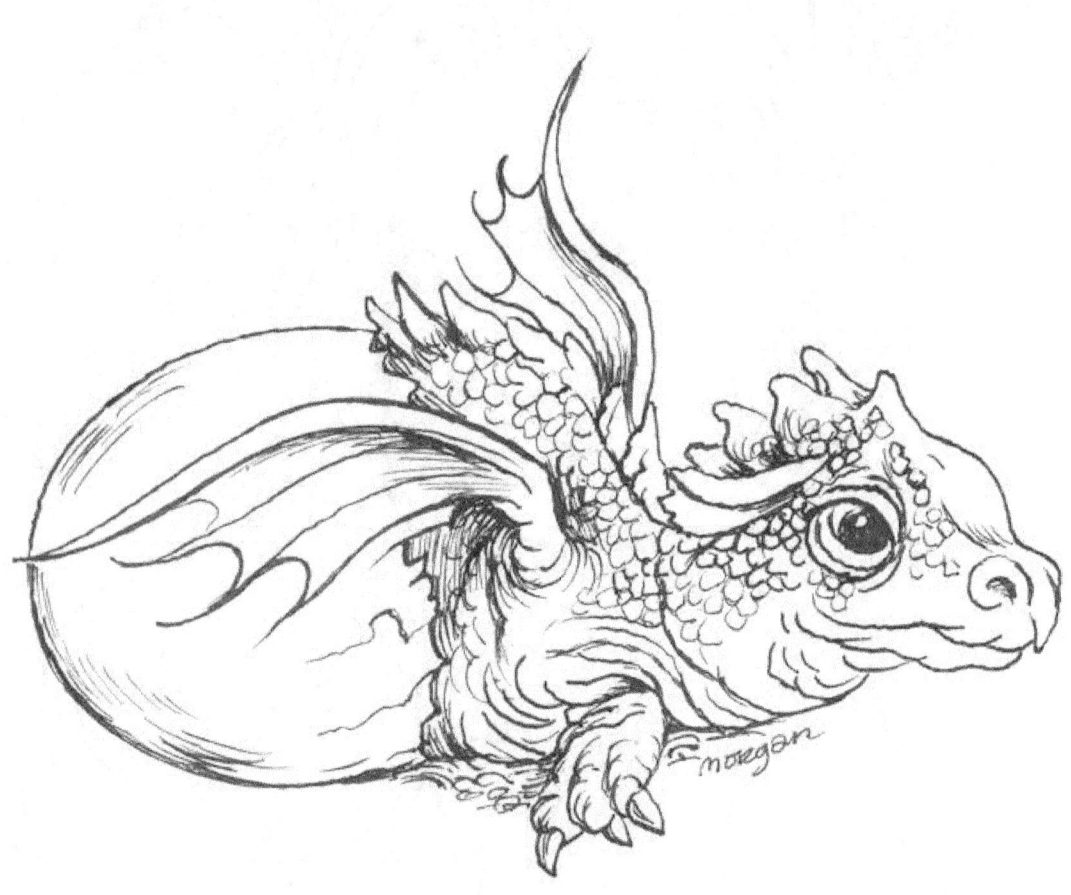

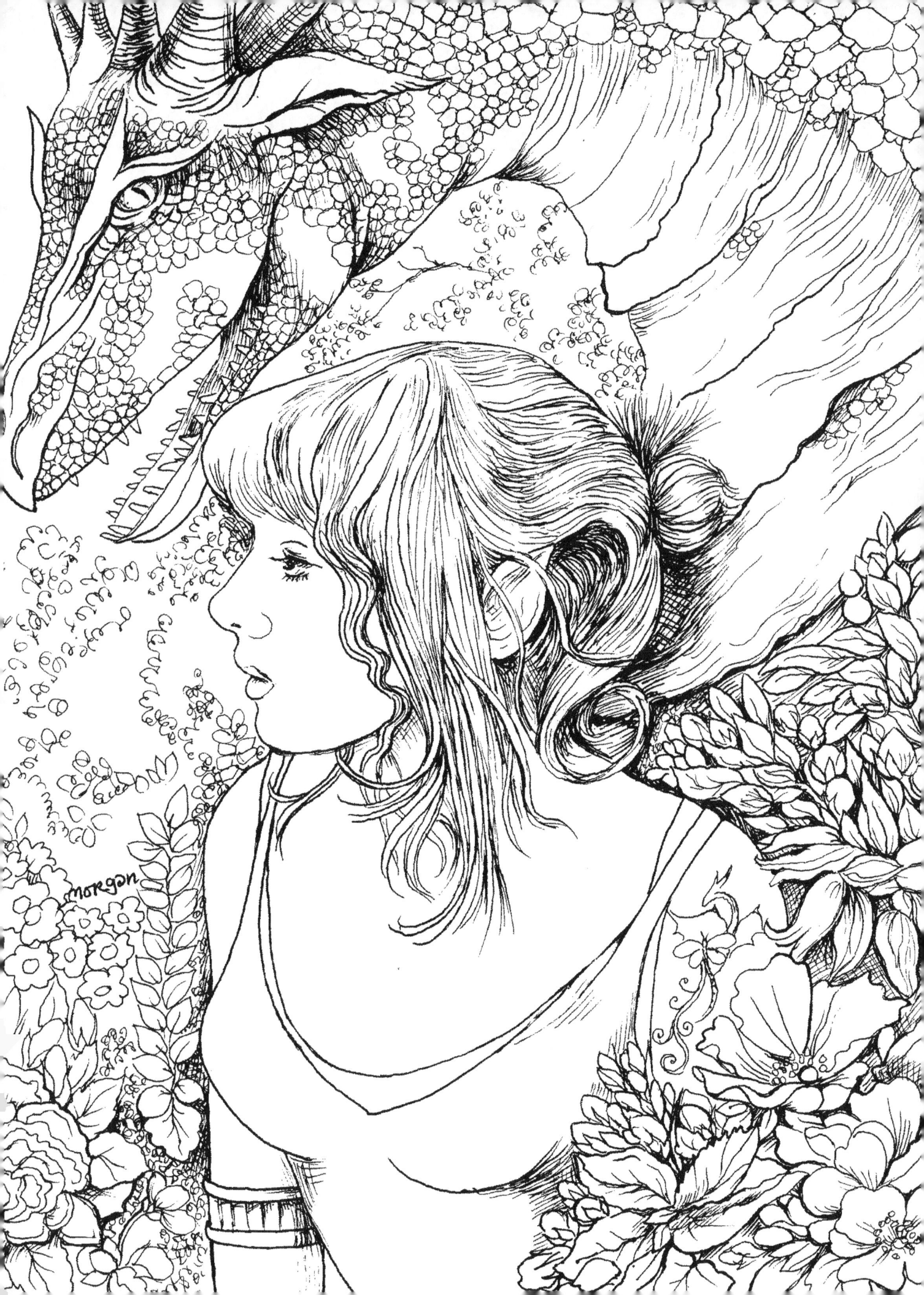

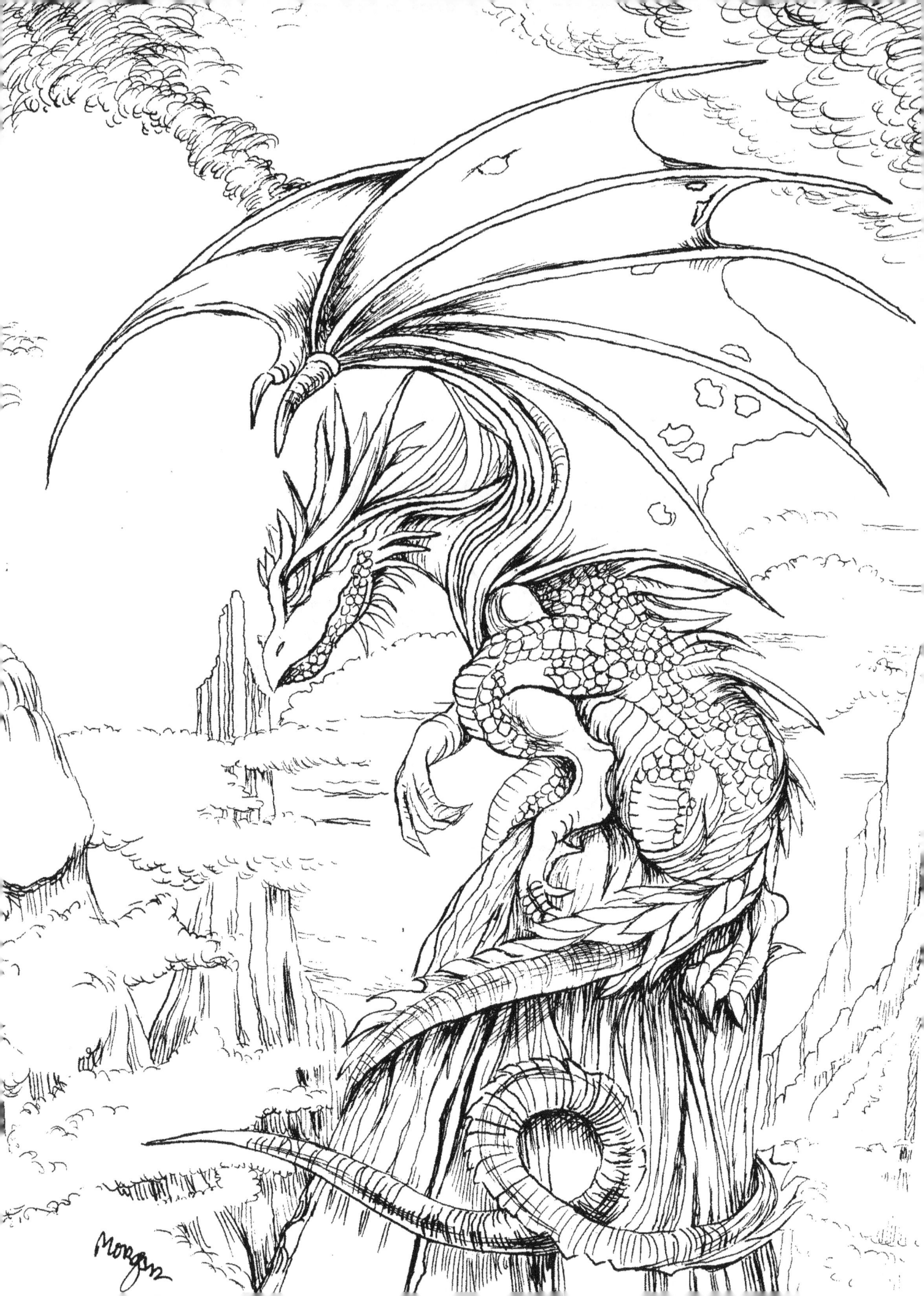

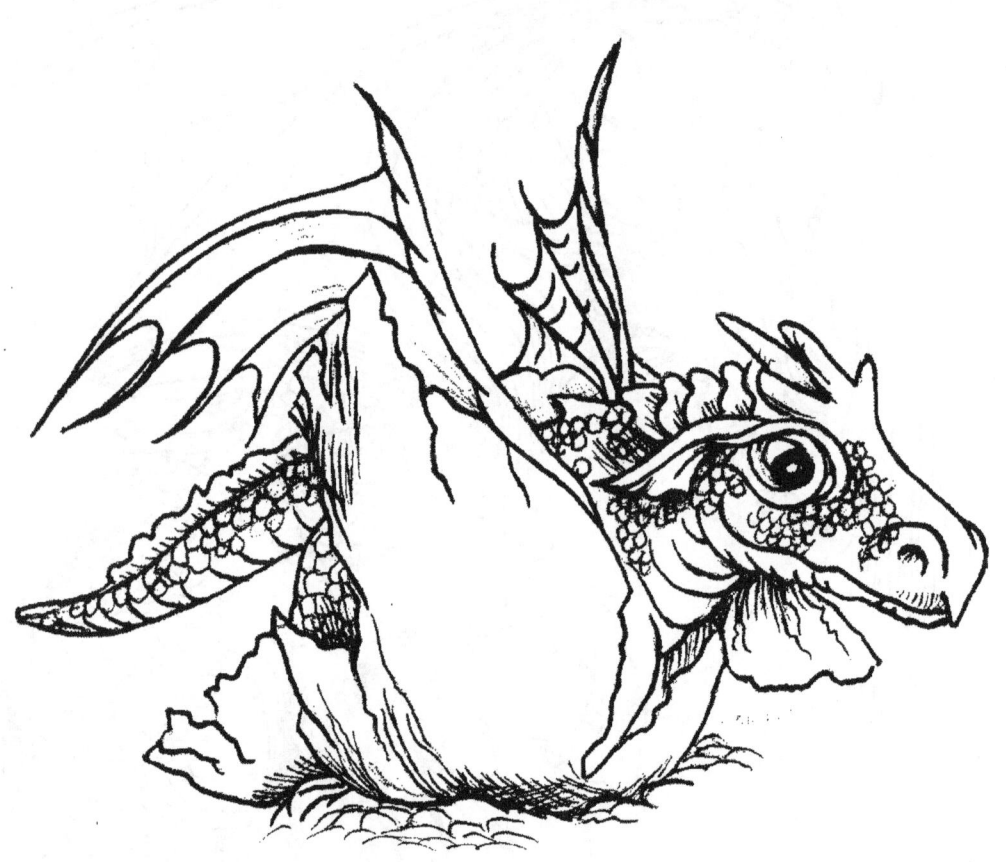

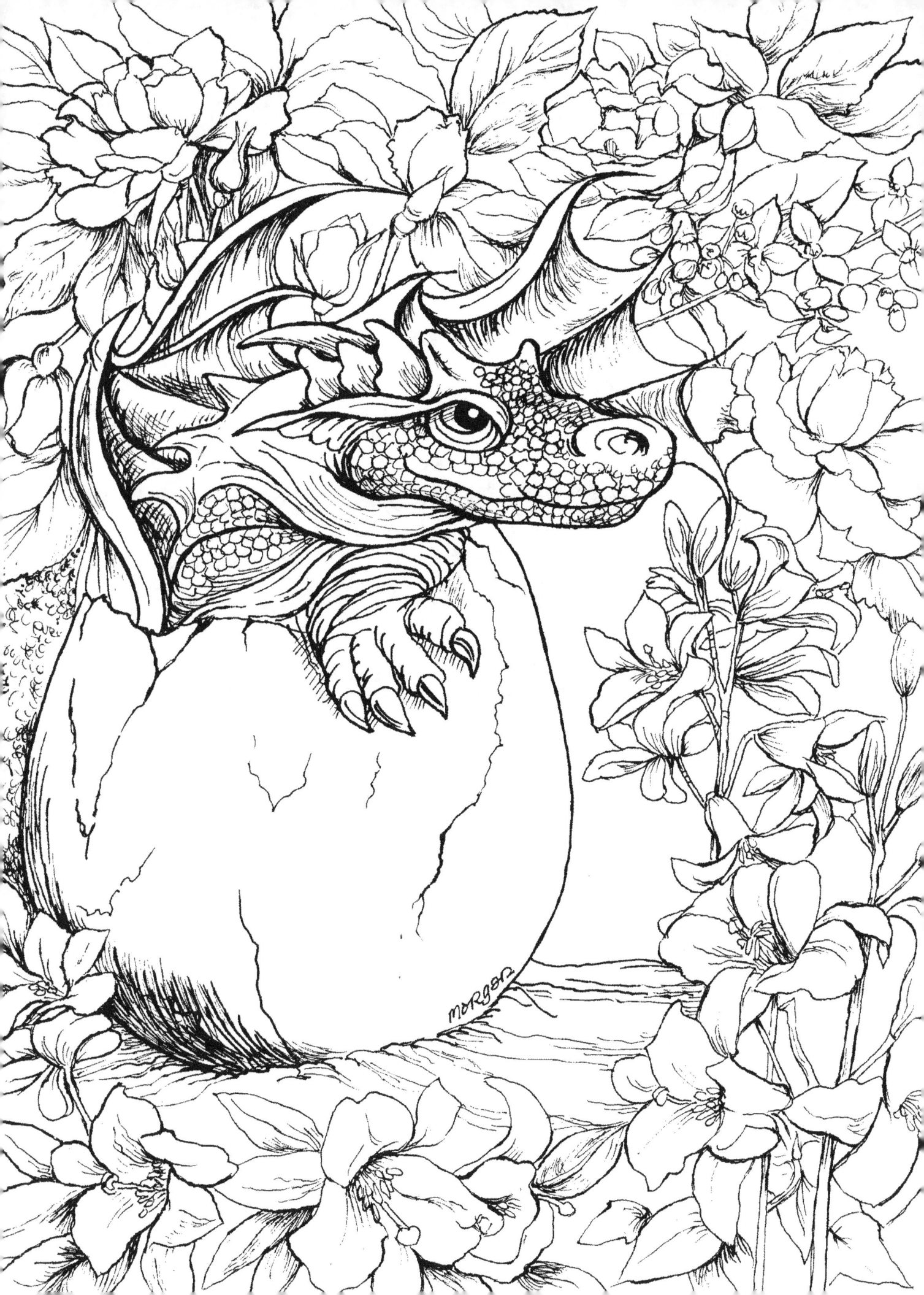

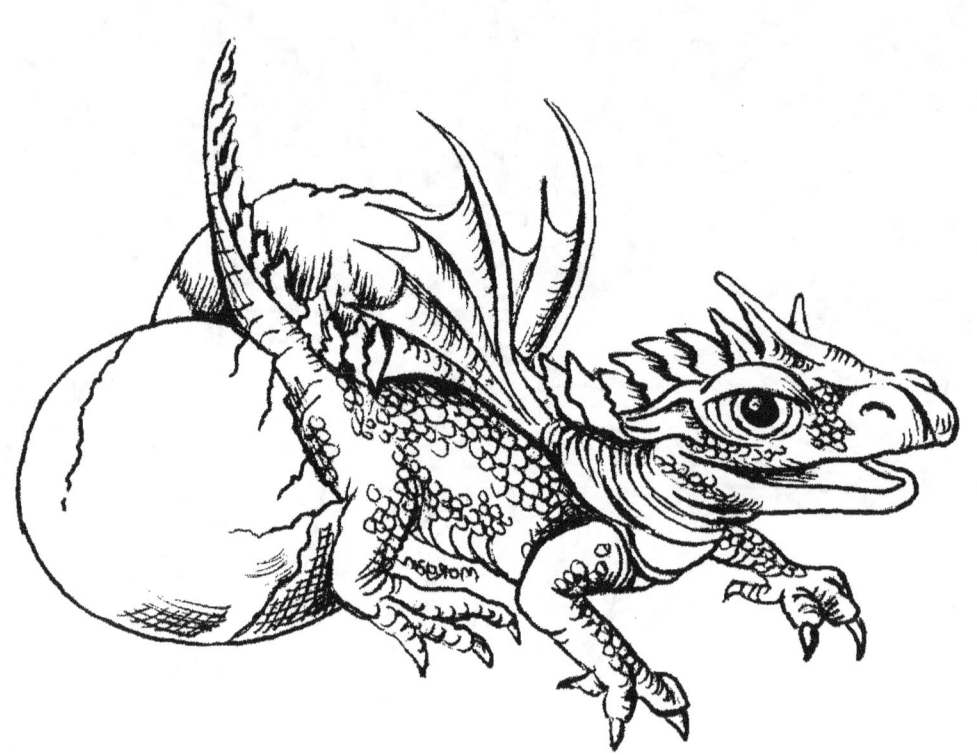

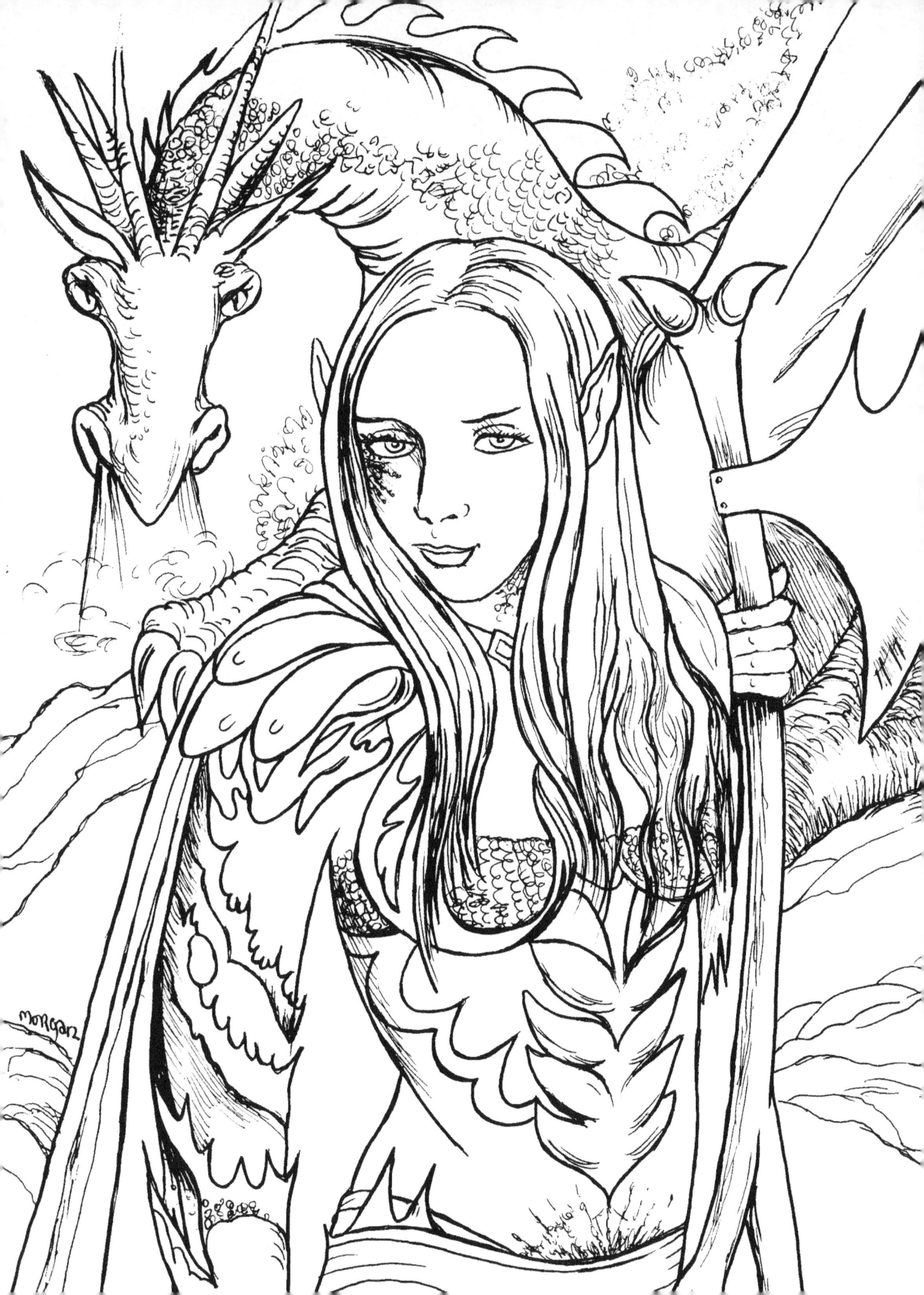

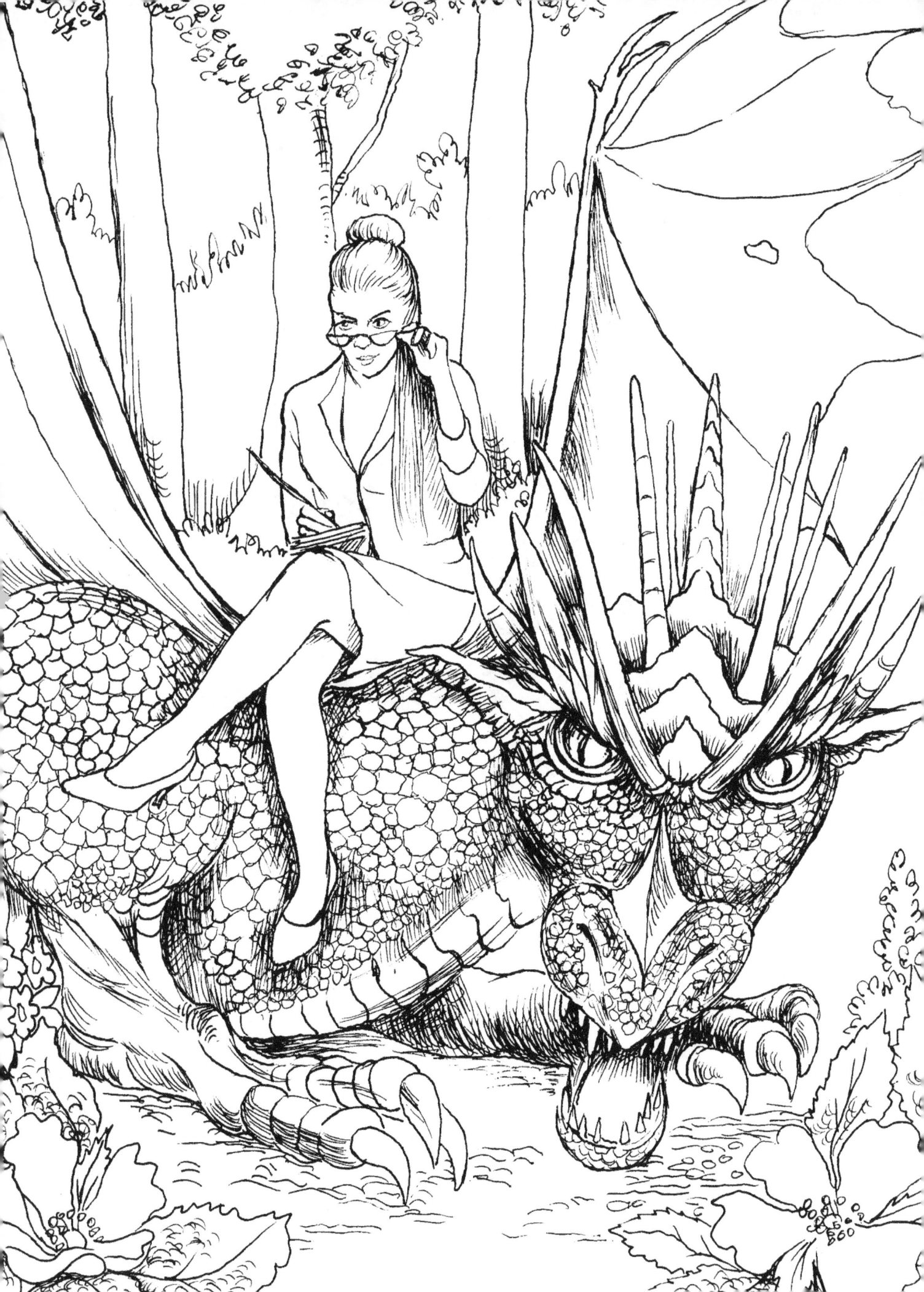

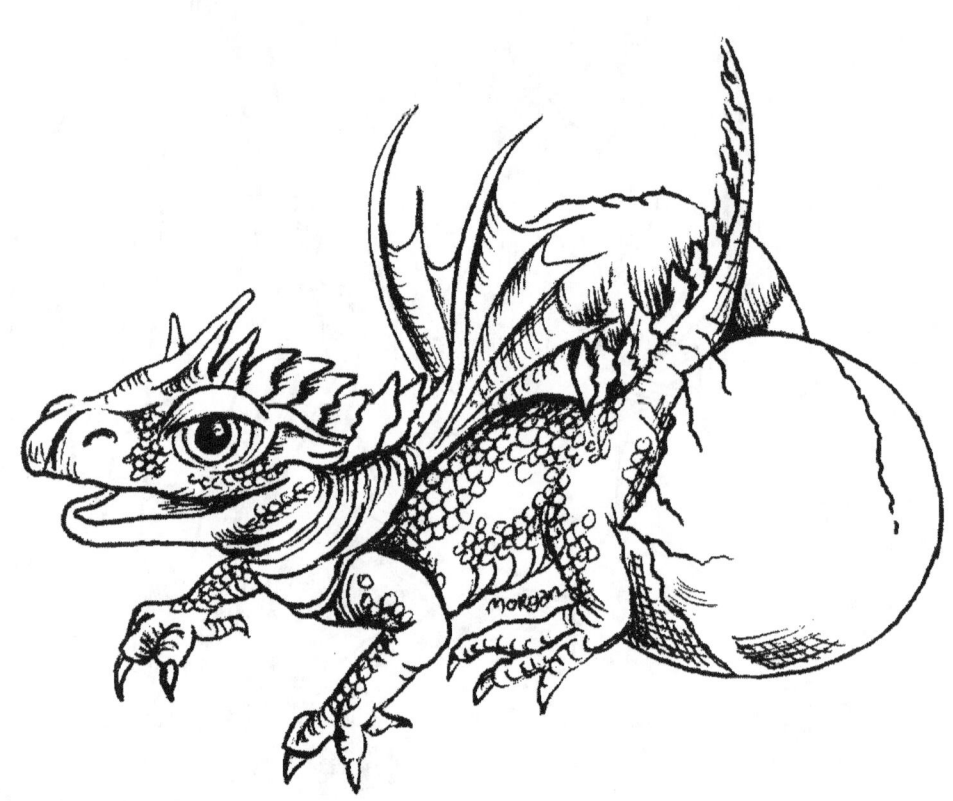

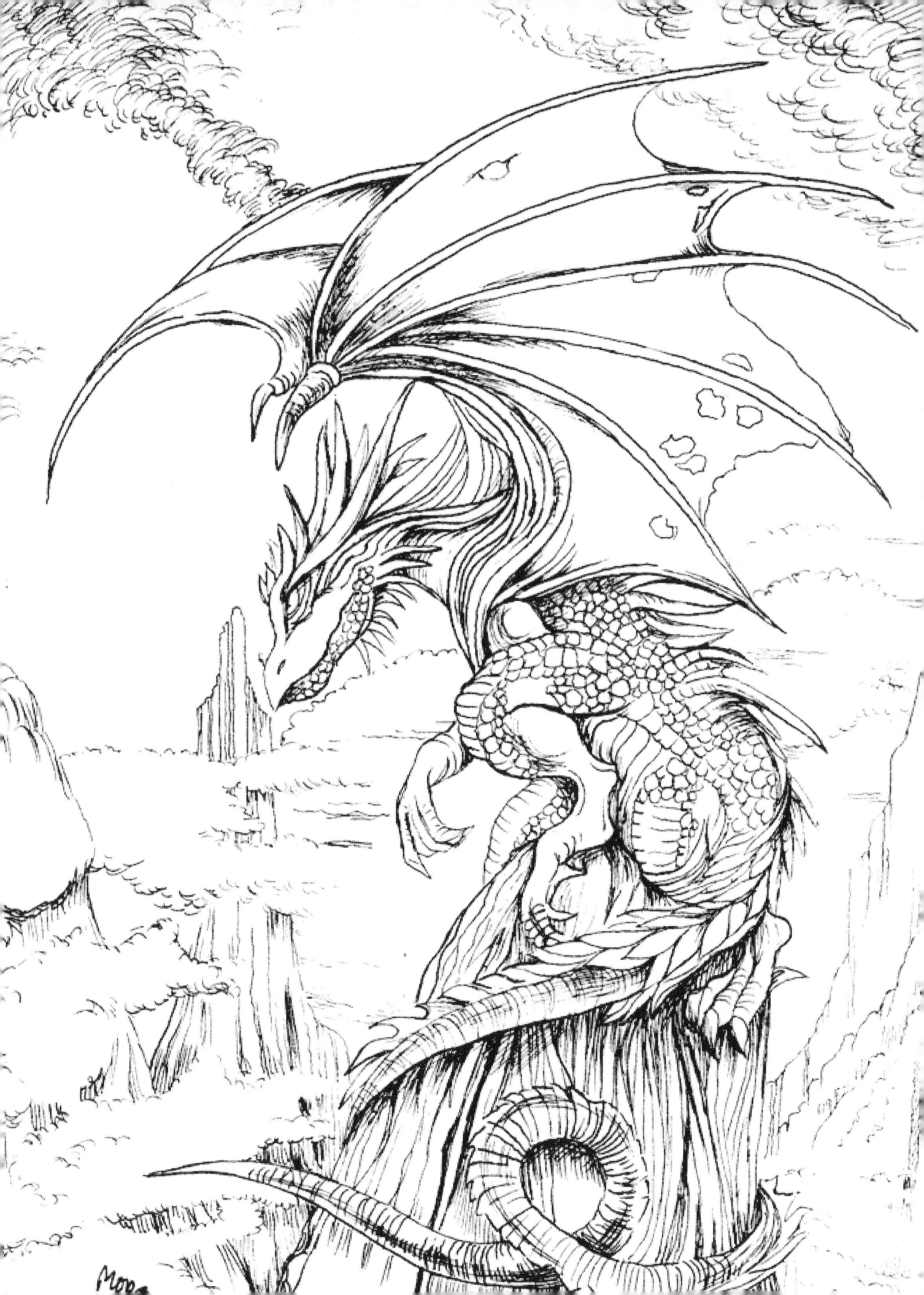

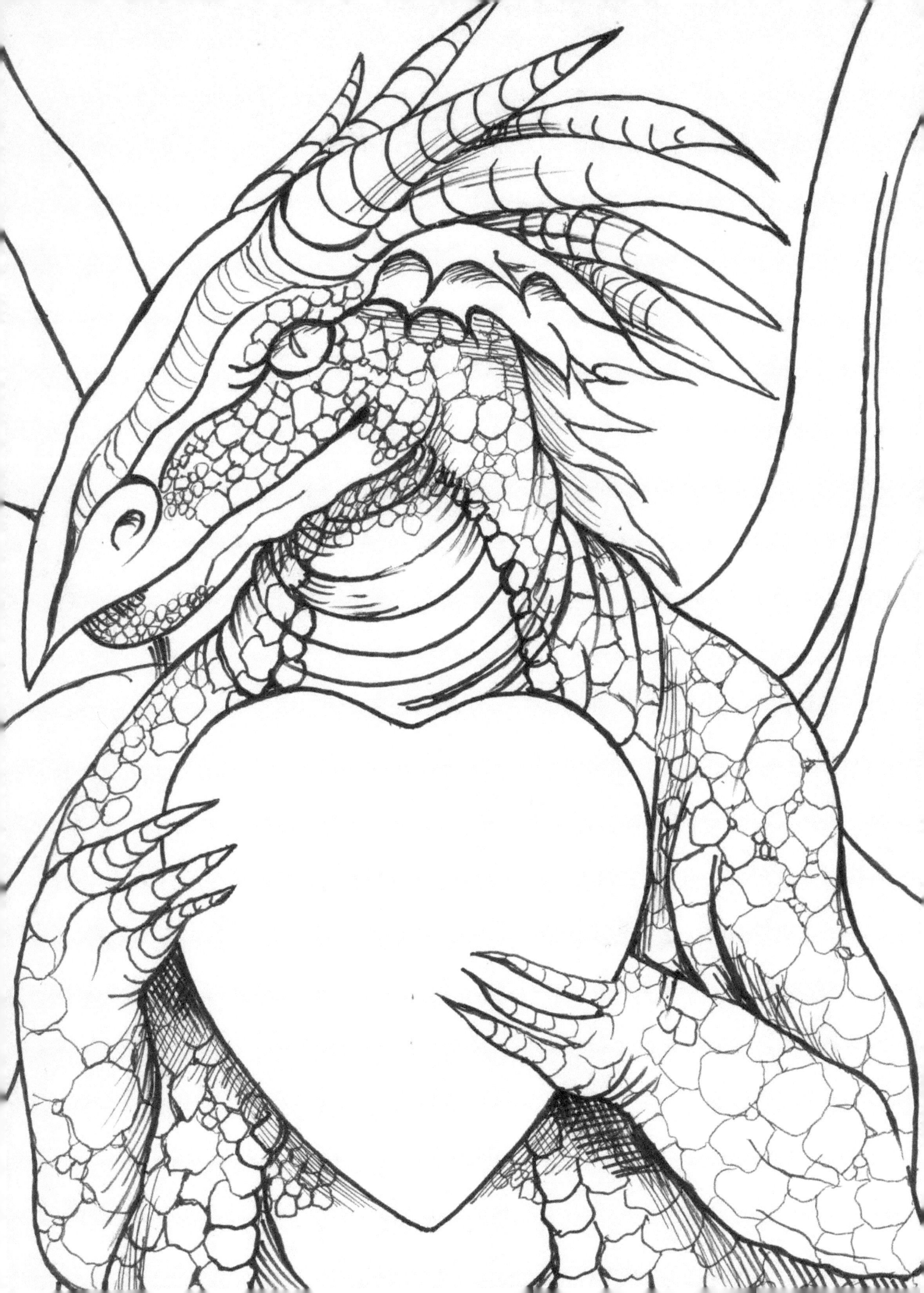

Pictures in this book: All the pictures are taken from paintings.

The reverse images are baby dragons or borders into which you can write or draw.

3. Belladonna and the ruby dragon - Belladonna is a character in The Last Enchanter series. She is an elf of the Dark Fields, her name taken from the Deadly Nightshade plant which is poisonous.

5. Another image of Belladonna from the second book, The Dragon Queen Rises - The dragon is the evil Talgit. The muse for the painting was the fantastic La Esmeralda.

7. Lilia from The Last Enchanter, the model is Olga the beautiful mother of my Russian muse, Alyonushka Volnogorskaya. They both look incredibly young.

9. The dragon was created for the cover of Dragon, Fly by my dear friend Jilly Paddock, and is now known affectionately as Jilly's Dragon.

11. Black Bryony and a red dragon from the Last Enchanter - Bryony is the unique black unicorn of the last enchanter.

13 The Sorceress of the Deep Wood and her dragons

15 The Emerald dragon and his rider

17. Dragon mother, featuring the most beautiful Alyonushka.

19 Belladonna with the dragon Belkis from The Dragon Queen Rises

21 The Earth Dragon and elf guardian

23 The Dragon Firedrake and her companion Arin from Enchanting Sarah - A fascinating tale of elves in our lifetime.

25 Dragon of the air and elf- minder

27 Dancing with Dragons

29 The Magical Twins

31 The Dragon Lady

33 Firedrake and Sarah from Enchanting Sarah

35. The Golden Dragon, from the Last Enchanter and also featured on the cover of The Dragon Lord's Library Volume 2 from the USA publisher 18th Wall.

37 The baby dragon Silvertrace emerging from the egg in Enchanting Sarah.

39 Kestia, a dragon guardian from The Last Enchanter, with her dragon.

41 The Dragon Lord, Calix. This is the cover of The Dragon Lord's Secretary from 18th Wall

43 The evil Kayla with her drake, from the book Enchanting Sarah